BETWEEN WORLDS

Contemporary Mexican Photography

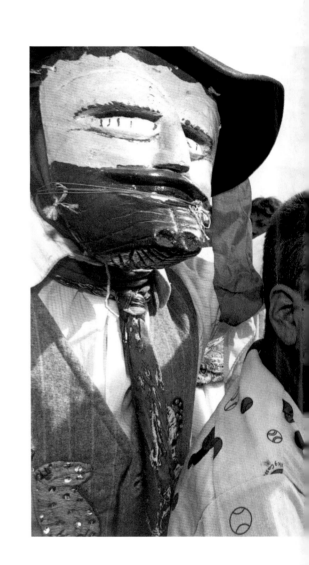

BETWEEN WORLDS

Contemporary Mexican Photography

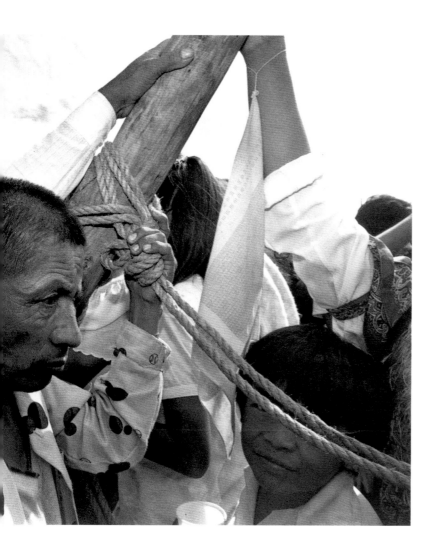

NEW AMSTERDAM NEW YORK

ᴬᴺ IMPRESSIONS BOOK

•1990•

Photographs copyright © Alicia Ahumada, Yolanda Andrade,
Adrian Bodek, Pablo Cabado, Marco Antonio Cruz, Victor Flores Olea,
Flor Garduño, Jose Hernandez Claire, Fabrizio Leon Diez, Eniac Martinez,
Francisco Mata Rosas, Pedro Meyer, Ruben Ortiz, Pablo Ortiz Monasterio,
Pedro Valtierra, Mariana Yampolsky.
Text copyright © Pedro Meyer, Carlos Monsivais, Augusto Orea Marin,
Ruben Ortiz, Elena Poniatowska, Juan Villoro, Eraclio Zepeda, Trisha Ziff

First published in the United States 1990 by
New Amsterdam Books
171 Madison Avenue
New York, NY 10016

Published by Arrangement with Bellew Publishing Co. Ltd, London

ISBN 1-56131-003-4

Published to coincide with
the exhibition **BETWEEN WORLDS**

Impressions
17 Colliergate
York YO1 2BN
England

Telephone (0904) 654724

Printed and bound in Holland
by Roto Smeets Ltd

Cover: 'Mass production', Mexico City ● **Ruben Ortiz**

Title page: La Villa de Guadalupe, Mexico D.F. ● **Pedro Meyer**

Publishers Acknowledgement
The publishers and authors wish to thank the following for
permission to reproduce extracts:

Carol Zabin, Michael Kearney, Carole Nagengasy, Stefano Varese,
*Indigenous Oaxacan Migrants in California Agriculture: A New
Cycle of Poverty.* California Institute of Rural Studies. Eraclio
Zepeda, *Bestiarium*, Argentum- U Bar Verlag Zurich. Jose Luis
Vazquez, *Huicholes: la tecnica del extasis.* Mexico Indigena,
November 1989. Octavio Paz, *The Labyrinth of Solitude*, an
Evergreen Book, Grove Press, Inc.

CONTENTS

*Self-discovery is above all the realization that we
are alone; it is the opening of an impalpable,
transparent wall – that of our consciousness –
between the world and ourselves.*

Octavio Paz, **The Labyrinth of Solitude**

Don Felipe Alvarodo's fibre glass horses, San Bernardino, California, USA ● **Eniac Martinez**

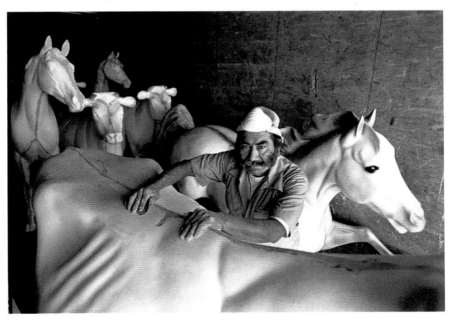

BETWEEN WORLDS

Contemporary Mexican Photography

PHOTOGRAPHERS

Alicia Ahumada
Yolanda Andrade
Adrian Bodek
Pablo Cabado
Marco Antonio Cruz
Victor Flores Olea
Flor Garduño
Jose Hernandez Claire
Fabrizio Leon Diez
Eniac Martinez
Francisco Mata Rosas
Pedro Meyer
Ruben Ortiz
Pablo Ortiz Monasterio
Pedro Valtierra
Mariana Yampolsky

WRITERS

Carlos Monsivais
Augusto Orea Marin
Elena Poniatowska
Juan Villoro
Eraclio Zepeda

EDITOR

Trisha Ziff

Editing this book and exhibition has been one of the most pleasurable experiences of my life. The reason I feel this is a direct result of the friendship and hospitality I received from all the people I worked with and who made this project not only possible, but 'theirs'. Without exception, all the photographers whose work you see here gave far more to this book than their images – their support was unending. The preparation took up copious amounts of time. The photographers invested both their energy and their personal funds. People were always willing to help me in many different ways – from translating texts to providing me with car rides – but above all in helping me understand the nuances of their culture and history. We would all meet regularly at the home of Pedro Meyer, and it was around his table that this project (the book and exhibition) took shape. Jose Hernandez Claire travelled to every meeting overnight by bus from Guadalajara (a journey of 600 miles), always arriving enthusiastic and with a bottle of special tequila from his home town. During these meetings we discussed our ideas and looked at each other's work. There were a variety of problems that we had to overcome. A major hiccup concerned funding, which resulted in a serious cut-back in the production of new photographic work. On hearing this news, the photographers unanimously decided to continue their projects at their own expense; a commitment of significant value on the part of everyone.

In particular, I would like to thank Marco Antonio Cruz and Jose Hernandez Claire for undertaking photo-essays necessitating their travelling thousands of miles at their own expense; Francisco Mata Rosas, who participated in the show even though many of his negatives and slides were stolen; Ruben Ortiz, for persevering despite all the problems of shipping film to the United States for processing, and having to wait weeks before seeing the outcome of his work; Victor Flores Olea, President of the Consejo Nacional para La Cultura y Las Artes, who in the midst of all his governmental responsibilities had time to participate with his own work; and Pablo Ortiz Monasterio, who assisted with editing the Mexico City section of the book and gave advice with the design.

There are many other people whose work is not directly visible in this book, but who freely gave of their time: Marcela Ramirez of the British Council in Mexico; Raul Ortiz, Minister for Cultural Affairs at the Mexican Embassy in London; Ana Maria Linares, who translated many of the texts; Ben Richardson from Metro Photographic Limited; Chloe Sayer, Colin Jacobson and Sylvia Stevens, who gave me their personal support. I would also like to thank Paul Gates and Chris Cox from Kodak UK Ltd and Jorge Pratt from Kodak Mexicana, for supporting us with photographic materials both for the exhibition and for this book.

Several people gave enormous amounts of their own time to make all this possible, and they deserve my very special thanks: Yolanda Andrade, who was always at the other end of a phone and who would organize all our meetings, contact photographers, chase writers and act as my translator; Mariana Yampolsky, who worked tirelessly on my behalf from the outset in making me aware of a wide range of Mexican photography and who, right up to the eleventh hour, helped translate and put the finishing touches to some of the texts; and Pedro Meyer, who for one year gave fifteen photographers access to his home, allowed us to use his equipment and telephone, disrupt his own personal work and life, and in all the mayhem, never complained. Above all, he gave me his continual advice, insight and enthusiasm. Thank you.

I also want to thank Paul Wombell, Director of Impressions Gallery, York, England, whose commitment to broadening the horizons of photography in Britain inspired this project.

This project was a true collaboration and meeting of two worlds, and was jointly funded with the support of the Arts Council of Great Britain and the Consejo Nacional para La Cultura y Las Artes in Mexico, and Visiting Arts.

I hope that this project will prove to be one of many collaborations of this nature between photographers, between our countries, *between worlds*.

Trisha Ziff
February 1990, London

BETWEEN WORLDS

Monumental head of Benito Juarez, Mexico City ● **Pablo Ortiz Monasterio**

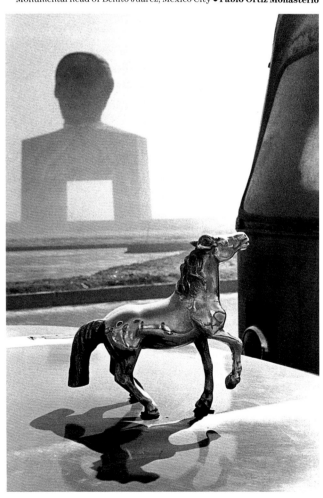

Between Worlds is a collective effort undertaken by a group of Mexican photographers to put together an exhibition of Mexican photography and writing specially commissioned for this book. The photographers represent a broad spectrum of Mexican photography; some are well established and known internationally, others are young and known only within their country, but what all their images share in common is a search to discover and acknowledge a diversity of events that touch Mexican culture.

Our objective was to make the work of all these artists available to a wide audience. For those of us from the First World, their views offer us greater possibilities to see beyond the exotic. This project is a link between our worlds: Third and First; Hispanic and Anglo, and so on.

It provides an opportunity to exchange ideas, to learn about a culture outside our own immediate experience.

There is a tendency within the First World to perceive 'creators' in many fields of the arts from the Third World as exotic. Their work is often marginalized, viewed and experienced outside the mainstream galleries, theatres, museums, and concert halls. The exotic has *caché* when it is in vogue, but when this is no longer the case, it is soon forgotten and becomes *passé*. Today, in the high-wage economies of First World countries, there is a continual search on the part of a cultural and class elite for new possibilities for consumption, a desire for new experiences. For example, in Britain so-called 'world music' became very popular in the late 1980s. There are now television and radio programmes, clubs and so on, which play music exclusively from other cultures. We enjoy the rhythms and sing the songs often without knowing what the words mean or appreciating the music's cultural origins. A multitude of international foods is also available for our consumption. We can buy ready-prepared Indonesian foods, for example, to serve at home, without our having any idea of how to prepare it ourselves, and, possibly, not even knowing how to find Indonesia on a map.

The French women's magazine *Elle*, now produced in sixteen editions, is tailored for the specific markets of different countries. One month women are encouraged to dress in the 'style' of Tsarist Russia and to eat caviar; the next month to wear embroidered Mexican dresses with ribbons in the 'style' of Frida Kahlo and to eat *tacos*. The 'looks', tastes, colours of the shrinking world are apparently available to us without our having to leave home, and they change at an alarming speed. Our malls and supermarkets become a sophisticated 'Disneyland'. We graze the shelves for pre-packed 'safe', assorted international goods. Yet while our desire to consume the exotic has broadened, has our knowledge? What do we know of the people who originally created the goods which enrich our lives, of their histories, their cultures, their realities? In the absence of such a context, we are encouraged, through the media, to resort to crude stereotypes.

The 1990s could well be a decade where political emphasis shifts away from North/South to focus on an East/West axis. Reflecting this trend, galleries will fill up with East European art, photography and design. As the first 'Big Macs' are consumed in Moscow, Soviet food could well become chic in London and New York – the new exotic. Already, in

Horse of Foyaltepec', Oaxaca, Mexico ● **Flor Garduño**

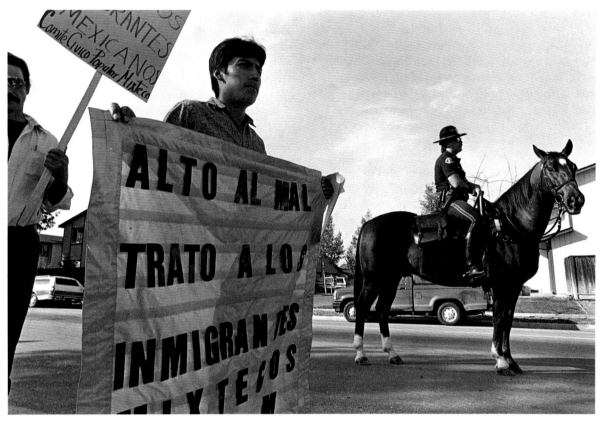

Demonstration in San Jose, California, USA ● **Eniac Martinez**

the United States, Soviet jeans are becoming as
fashionable as 501s and Barbie's new boyfriend is
called Gorby. Yet, in all the excitement, there is a
danger of ignoring the differences between North
and South, between Third World and First –
differences 'we' (from the First World) created.

In Britain during the late 1980s 'Latin-style'
became increasingly popular. 'Tex-Mex' restaurants
sprang up in major cities, and a variety of Mexican
beers became available for our consumption. More
specifically within the visual arts, several major
exhibitions took place. The Hayward Gallery in 1989
presented *Art in Latin America*, and a touring show
of the work of Posada was shown in several major
venues throughout the country. Examples of this
developing interest were also to be found in the
goods that were produced to be sold in conjunction
with these events. Dancing skeletons, derived from
Posada's engravings, appeared on the labels of
Mexican beer bottles in British supermarkets and on

Tee-shirts, postcards, and bags. Up until now,
photography, for the most part, has been largely
ignored.

Yet photography plays an important role within
the Mexican cultural tradition.

Photography arrived in Mexico within three
years of its European discovery. It became
immediately very popular; photographs were taken
in rural areas far away from towns, and people
walked for miles to have their pictures taken. In
most Mexican homes a family portrait was placed in
a prominent position on the wall alongside the
picture of the Virgin of Guadalupe. A leading
portrait photographer, Romualdo Garcia, worked
during the late nineteenth century in Guanajuato,
photographing people from all walks of life, but
always in front of the same backdrop.
His work gives us a rich insight into his subjects, who
reveal their personalities with a candidness that is
quite amazing, whether they be bishops, courting

couples, Zapatistas or members of the ruling class, actors, musicians, peasants, children alive or dead; their portraits provide a wealth of information about Mexico at a time of transition from Independence to Revolution. This documentary tradition took on greater significance at the time of the Revolution in 1910 with the work of Casasola and Lupercio and has continued throughout the century in the works of Alvarez Bravo and Nacho Lopez.

It has become customary for First World photographers to visit Mexico as visual explorers, inspired by the richness of the culture and street life, attracted by the fiestas and rituals in a country so different from their own. For the most part, it is their photographs that we see, their perceptions, their choices. It is their images which appear in the majority of international publications. Consequently 'our' image of Mexico is created almost entirely from such images, or from what we hear on the news, or from what we see on Hollywood movies, cartoons, and so on. All of this results, inevitably, in our being presented with an exlusively external view.

Such views from the outside can have their own merits and are not necessarily inadequate just because they do not come from that culture itself. However, when the people *are* able to speak for themselves, they contribute insights which can easily elude those from abroad.

For example, over the past fifteen years Latin American photographers have presented us with a dialogue not only among themselves but with the rest of the world. In 1978 the first colloquium of Latin American photography was held in Mexico City, a second in Mexico in 1981 and a third in Havana in 1984, as well as the first book in the *Rio de Luz* (River of Light) series (produced in Mexico by the Fondo de Cultura Economica). Since then another eighteen books have been produced, all dedicated to showing the work of Latin American photography. As a result, those of us from outside have had an opportunity to see some of their work and expand our knowledge of Latin American photography.

For photographers working in the Third World, issues that in the First World one would never consider become part of day-to-day reality. Photographic materials, when available, are extremely expensive. Making images in this context therefore takes on new dimensions. A photographer visiting Mexico from the First World to make a simple reportage assignment will think nothing of shooting 150 rolls of film; Mexican photographers rarely have the opportunity to work with these quantities. Paper and chemicals are not always available, so for instance, photographers are less able to explore materials and to have control over them. Continuity, so basic to determine outcome, becomes a luxury.

None of this is said as a complaint, it serves merely to define a context. Creative freedom cannot be measured by the amount of 'stock' in the fridge. In Mexico there is a limited photographic market. In marked contrast to the First World, there are few magazines that use photographs. Mexican photographers rarely fall into the trap of making images which are indistinguishable from advertisements, because there is less pressure on them to produce a 'sellable' style of photograph. The constraints of the marketplace and the pressure of competition do not exist in the same measure. This creates a climate where other values and perceptions can emerge. Photographers have the opportunity to reflect, to examine their own culture and to find considered visual explanations in a society and culture which nurtures this way of working. The 'quick fix' way of seeing is alien to Mexican culture.

Octavio Paz said, 'The Indians are the bones of Mexico'. The rich cultures of Mexico's indigenous peoples are not confined to museums or reservations, but form part of daily life. Theirs is a living culture. As outsiders, we read this combination of past and present as surreal – it is outside our experience. Yet the longer one remains in Mexico, the more apparent it becomes that the present and the past, the pre-Hispanic and the Occidental, cannot be separated, they have become interwoven. There are, in addition, other influences: the relationship of Mexico to its northern neighbour, the most powerful of First World nations, contrasts starkly with its southern neighbour Guatemala, a country poorer than Mexico and fraught with its own internal political problems. The photographs and writings in this book reflect many of these concerns and picture life in these different worlds: from the rural Mexico of Flor Garduño's 'Bestiarium' full of images of men and women with their shadow-animal twins of pre-Hispanic tradition to the work of Ruben Ortiz, full of vibrant colour, neon Aztecs, electric virgins, a

cacophony of brightly painted idols filling the streets, cafés, garages and shops of the city.

Crossing the border to the United States, Pedro Meyer is working on an in-depth project photographing his personal vision 'Inside the USA'. In his text he states, 'The dynamics generated by sharing the largest border anywhere between First and Third Worlds make it imperative that we look in detail at the inner workings of our neighbor.'

The work of Eniac Martinez also crosses this border, documenting a group of the Mixteco Indians, people who are forced to migrate to the United States from their home state of Oacaxa in search of work and find themselves in a strange world. These photographs are a visual journey composed of images from both Mexico and the United States. For the Mixtecos, everything is foreign; for many, speaking Spanish is new. They thus find themselves between worlds, in danger of belonging, ultimately, to neither.

Mexicans have a history involving colonization, independence and revolution, and are therefore imbued with a strong sense of autonomy and self-determination. Zapata's cry for 'Land and Freedom' remains important to people today. His image is an icon in popular culture. While Adrian Bodek chose to photograph living Zapatistas, another photographer, Marco Antonio Cruz, focused on the south of the country, on Chiapas and the coffee haciendas. There, he documented the conditions of Guatemalan migrant coffee workers, conditions belonging to pre-revolutionary times.

Mexico is an enormous country, approximately the size of Europe. Although Spanish is the dominant language today, Mexico's peoples speak fifty-seven different Indian languages. The capital, Mexico City, is the largest city in the world, with a population of over twenty million, a huge and diverse *megalopolis*.

Many people, especially men, are forced for economic reasons to leave their homes and move to the city in search of work. As a result, there are many villages inhabited predominantly by women, old people and children – places without men. The women find themselves forced to enter male worlds, carrying out new roles. Mariana Yampolsky photographed the women of the Mazahua, their daily lives and rituals. Alicia Ahumada has been working in Hidalgo, photographing the isolation of the women in the mining communities.

There are also those peoples who remain together, such as the Huichol Indians, fierce in their determination to maintain their culture and language, their rituals, their world; photographed by Pablo Ortiz Monasterio.

The photographic community in the First World perpetuates a myth about its own self-importance. The written history of photography makes only minor reference to those outside the mainstream. In *Life* magazine (February 1990) there is a photo-essay by Czech photographers on the changes that have recently taken place in Prague. Although this in itself is a significant change of practice (historically, news events are generally seen primarily through the eyes of First World photo-journalists), the magazine cannot help revealing its perception of self when it compares a photograph, taken by Roman Sejkot in Wenceslas Square of a couple embracing, to Alfred Eisenstaedt's picture taken in Time Square on V-J Day in 1945. The meaning conveyed by the text suggests that Sejkot's is a great photo because it is like one of 'our' photographs. Czech photography cannot be seen independently. In other words, as we are led to believe by the accompanying caption, its merit resides in its apparent similarity to a well-known image produced by an American photographer.

In contrast to such ethnocentric perceptions, one can only state that the images in this book stand up to the most competent photography anywhere. The work here does not intend to celebrate or emulate any images created at other times or in other places. The images are derived mainly from the photographers' own strong cultural tradition, the references are to themselves, even as they acknowledge the 'history' of photography elsewhere.

Trisha Ziff
February 1990, Mexico City

SURVIVE to CELEBRATE

Pablo Ortiz Monasterio

Among the Huicholes, the creation principle is personalized in *Tacusi Nacave* – 'Our Grandmother Growth' – mother of the gods and the goddess of fertility. Man is a product of gods and as such he depends on them and has duties to fulfil. But gods also depend on men; offerings, sacrifices and prayers are their food. These 'man-gods' relationships should be reciprocal, creating a dynamic balance which is simply the reflex of the existing relations in nature and society. In order to have long life and health it is necessary to maintain this balance with the gods, the relationship between the sacred and the profane, the natural and social. This is achieved only by the following 'custom', *virrarika yeiyarieya*, which is the Huichol way of thinking. The cultural scheme of the group is 'to satisfy the gods, to hunt deer and to make the party'; that is what is meant by leading a perfect life within the framework of Huichol thought. Everything that goes against 'custom' will bring illness and death. Illness itself is not a threat to the body but to the spirit, and even more to the cultural survival of the group. In this way, illness is assumed to be a way of going against the natural order of things, a social act religiously expressed and manifested by the intrusion of foreign objects in the body of the sick person.

Jose Luis Vasque
MEXICO INDIGENA, November, 1989
Translation: Ana Maria Linares

The Huichol Indians live in the North West Sierra of Mexico in the state of Nayirit. These dances are a fertility ritual; they take place before the rainy season begins. The dance is a sacrifice, a pledge to the gods. The men, women and children dance for several days.

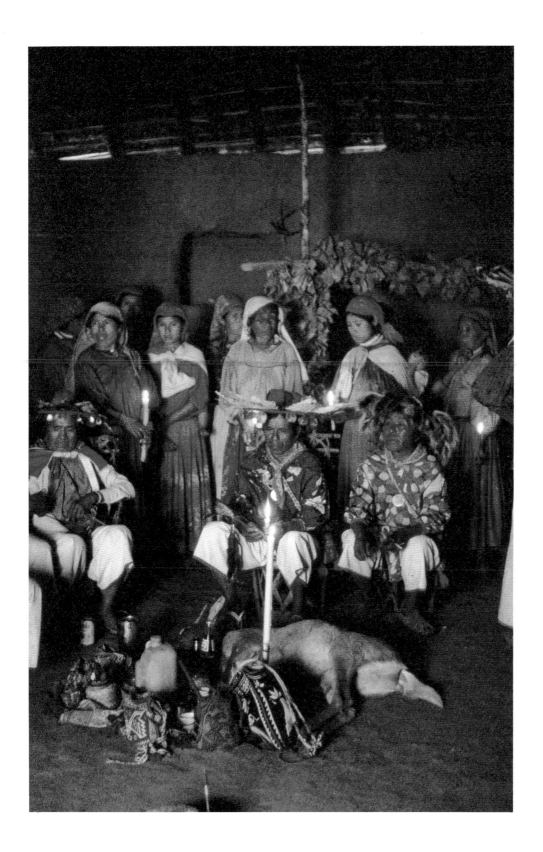

17

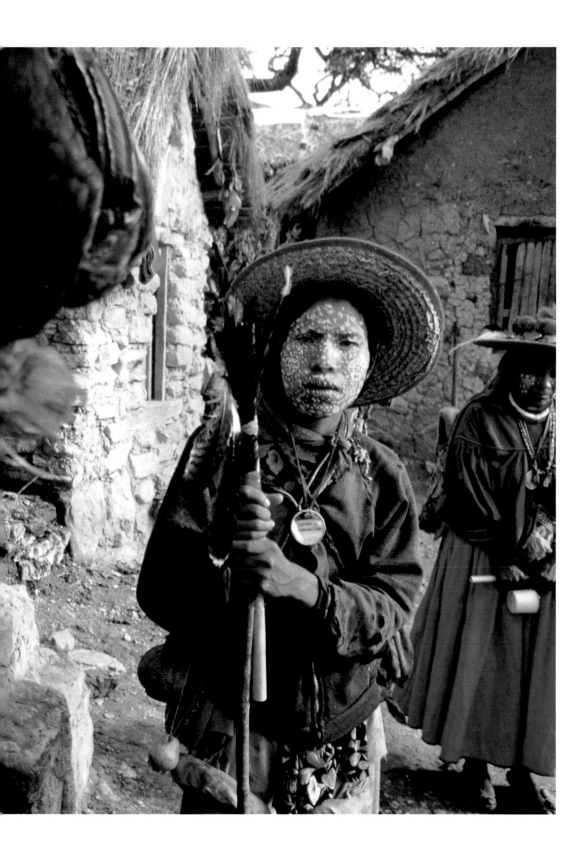

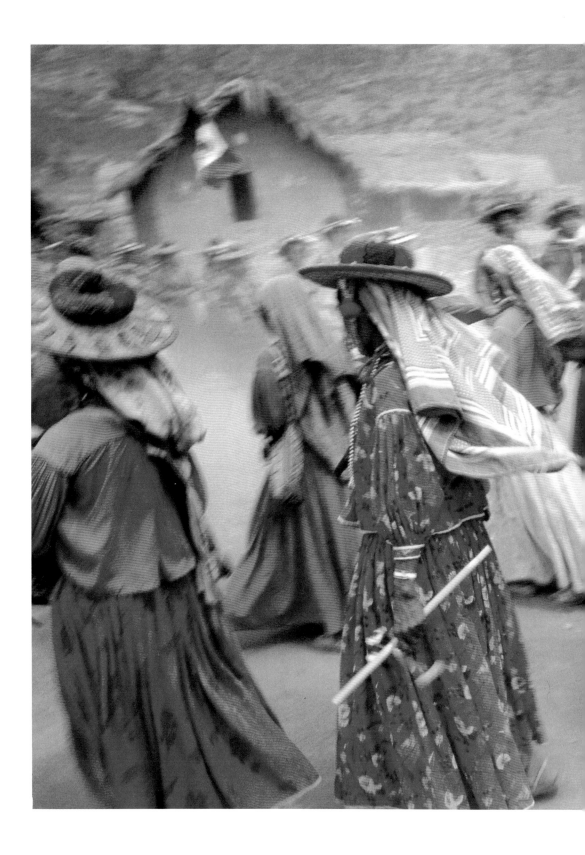

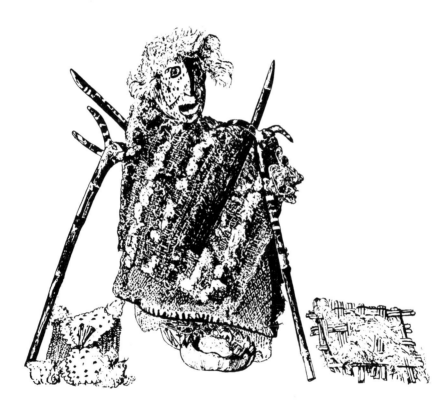

La Madre de los Dioses · Grandmother Growth

Illustration of Grandmother Growth from *Symbolism of the Huichol Indians* by Carl Lumholtz

BESTIARIUM

Flor Garduño

Woman, Juchitan, Oaxaca, Mexico

BESTIARIUM

In the south of Mexico, when your child is about to be born, you should draw an ash circle around the house at the time the mother feels her first labour pains. This circle has to be wide enough to allow nothing to escape.

We come to this world with a brother animal, a double creature, a twin in the woods. The newborn's fate will be joined throughout his lifetime to his corresponding good beast or fierce animal. It can be an eagle or a tiger or a fox or a coyote or a puma or bull or a tapir or a sparrow-hawk or a deer. These are all good twins, good mirrors for your child to look at himself in their eyes or to be whispered to by their secret words. It can also be a horse or a lynx or a rabbit or a dog or a cat or a cock or a turkey or a goose, which are not so good, but it is possible to live with them through time and the world. Or it could be worse: a hen, a chicken, a vulture or a pig. let not god nor the devil allow that!

The strength of the animal or the meanness of the beast will confirm the nature of your unborn child. His twin's cunning will be his intelligence. If he inherits clumsiness, he will walk stumbling and slipping during the time that he is allowed to look into the world. His gestures will be those of his guardian, of his non-guardian angel, of his *Tona* of the vanguard, of his *Chulel* of the rearguard.[1]

Draw an ash circle and wait for your child to be born. After he has been purified, welcomed, wrapped up and pampered, after he has blindly looked for his mother's breast, go out without fear, go out into the sun or into the shadows, enter the night and walk along the ash circle you drew. There, in the white-grey of a dead fire, in the ash, you will find inscribed the footprint of the animal your child has chosen as his twin. Let god protect him! If the animal has genius, he will be happy. If he is given a carrion's ravenous footprint, poor child!

This revelation will be a secret between the two of you. Nobody should know about it. If it is known, the child-youngster-adult-old man who is being born will be vulnerable: his destiny is the animal's fate. If the animal suffers, he will be in pain. If his twin dies, he also will not be able to see the dawn of the world. If a cowardly enemy knows the secret, he will look for the animal to hurt him.

An animal is waiting for all of us in life. He is here before us to name our souls, mark our steps, smell our fears, hawl-meow-bark-sing-cackle our way, until the very day of our danger and death.

You may believe animals are ours; don't deceive yourself any more: we are bound to them, their servants, their slaves; they are our masters – the true animals – and we are animals of those beasts, their inheritance.

Watch the steps of men and women. Observe how they walk, move, talk and laugh. If you look carefully, you will see the twin in each man and in each woman,: that one has the gesture of a tiger, talking emphatically with his hands; another knows his own strength and scratches the ground with his foot, he is a bull; this young girl slides as a cat on heat; that old man is a tapir, knocked down by sorrow; that vain man is inhabited by a bright red-and-blue macaw. A gay young girl carries a squirrel in her heart. A lonely and mean man has a vulture nestled in his guts.

The beast that follows you in life, the beast that announces death, the beast that helps you: horses with open lips pointing with a grimace at a snake that dreams about crime in the afternoon. Geese that watch the house better than bribed dogs. Female cats that pick up the souls of dead whores and wail at night, laughing and crying. The boastful cock embodied by the brave man murdered by the police several weeks ago now.

Animal of joy, the galloping 'merry-go-round' little horse changes us into children at each turn. Loud laughs of men spilled over a dog's eagerness jammed with his bitch, both withstanding the cold water thrown over them by a restless spinster.

Ignoring mirrors, a turkey dreams about being a peacock, proud, strutting turkey, to look at the daylight with all the eyes of his real-so-unreal feathers.

I have also watched the prodigious flight, arrow-tailed, of the surprised and surprising *quetzal*,[2] bird of our paradise that embodies freedom, in the most secret place high in the jungle, the winged dream of those being chased by troops who advance forming a lethal circle. At night our hands sweat and the restless flower of fear falls upon us by the presence of mournful animals: the owl that carries death on its shadowy wings the

silky and winding bat in flight beside the bewildered darkness of the poor earth-mouse who envies him.

Terror inhabits our house with the suspicion of evil animals: the unmentionable *cadejo*[3] with its sight inflamed by the fires of hell. The bridled female pig, tied up, on which elves ride and then run away over sleeping drunks. The eternal rabbit with its cut-off tail that jumps – jumping, fornicating with sad women and embarrassed boys. The snake that sucks the mother's breast during her deep sleep and at the same time puts its tail inside the hungry child's mouth. The turtle that takes off its worn-out shell to slip, naked, through the hammocks where old men dream of lovers long gone.

And Julia appears in front of me, my nanny, my father's nanny, brought up by my grandmother, turned one night into a goat which was her twin, half-bellowing and half-bleating, protecting her face from the terrible knife cuts her husband was giving her, because in the lost shadow of his drunkenness he could not distinguish his Julia from the goat. During all those long years of survival, Julia covered with her hair the sad hole where her ear used to be and she also hid the stumps where her fingers were and that had been cut off that awful night.

Those animals which are born as a punishment are taken to annual town fairs, and there we all go, surprised and gay, to meet the toad-boy, the snake-woman, the dog-grandfather, the cayman-girl, all fallen into disgrace as payment for uncertain sins.

For weeks, don Valentín Espinosa, an old game-cock gambler, tried to breed an eagle with a Cuban game-hen to create a winning breed. He prepared them an ingenious bridal-chamber for their forced love. Don Valentín's dream was shattered in the same way the Cuban's breast was torn out one afternoon when the seminal eagle decided to eat his impossible lover, cutting off with his beak all possibility of the arrival of a magnificent breed. Now don Valentín dreams about breeding bees with fireflies, to create honeycombs where these creatures would work day and night shifts in the honey factory and, besides, they would light up the nights in his backyard.

In my town, we say that skeletons fly at night and that they belong to those witches who have learnt how to shed their own flesh. Those young men who see them flying under the moonlight die in a terrible way. Filiberto Martínez took revenge on those crimes by putting salt on the abandoned flesh of some witches. At dawn, when they returned, the witches howled when they tried to get dressed, their flesh burnt by salt. Since then, they hide their naked skeletons during daylight.

One day in April 1982, the corridor in my house was invaded by hundreds of overwhelming animals, some of them deadly enemies joined by the brotherhood of fear. There I could see friends in disgrace, eagles and rabbits, worms and sparrows, snakes and hummingbirds and many small, blind animals fluttering, stumbling in the dark in that sulphurous atmosphere caused by the hot ashes thrown up by the volcano.[4]

Weeks and weeks later, at last it rained, covering the ashes for the first time. The world was green again and life returned to normal throughout the country and the animals went back to their homes. In the meantime, the descendants of Sonia Guerrero were flying around in the clean afternoon air: after seducing a wild goose she gives birth to angels each year. Some of them can still be seen flying away, especially at the beginning of the rainy season.

Eraclio Zepeda

Translation: Ana Maria Linares

Translator's Notes

1. The words *Tona* and *Chulel* are Maya terms and they both refer to this twin animal. In this text, they also mean the future (vanguard) and the past (rearguard).
2. *Quetzal* is the name of a very bright Mexican and Guatemalan bird which is also a symbol of freedom, protection and good fate.
3. *Cadejo:* evil coyote.
4. In April 1982, a volcano called *Chichonal*, located in Chiapas, erupted and many animals were killed and lots of houses were covered by the hot ashes, as well as the fields. A big area remained grey and the air was unclean and thick for weeks.

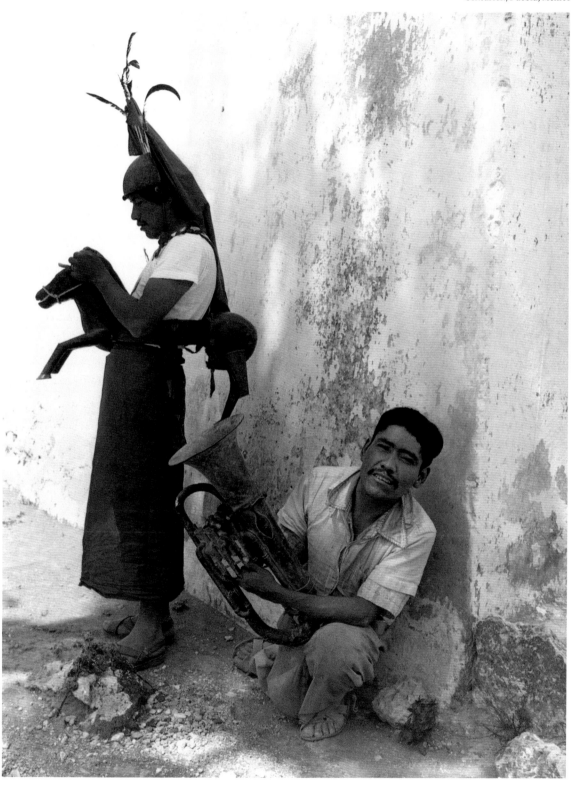

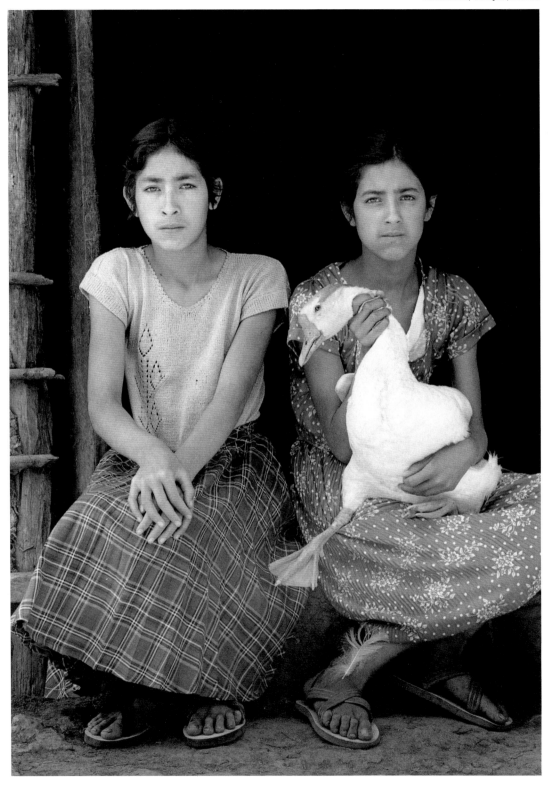

Armadillo, Guerrero, Mexico

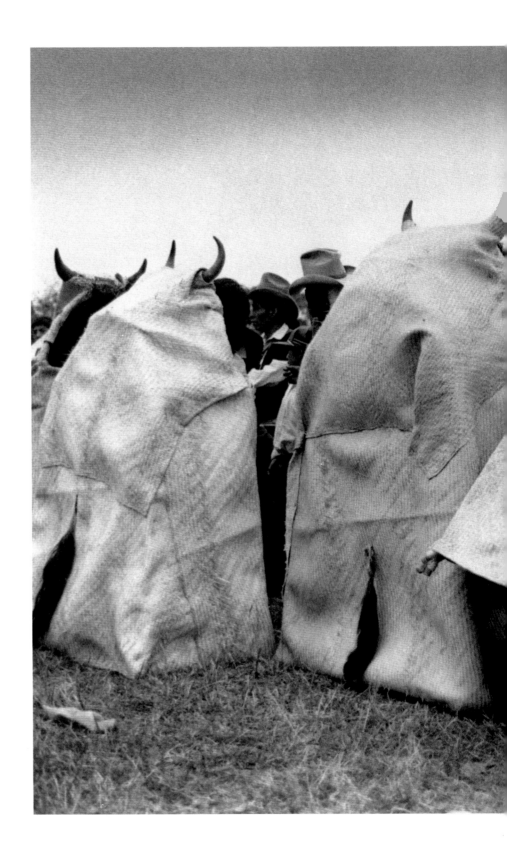

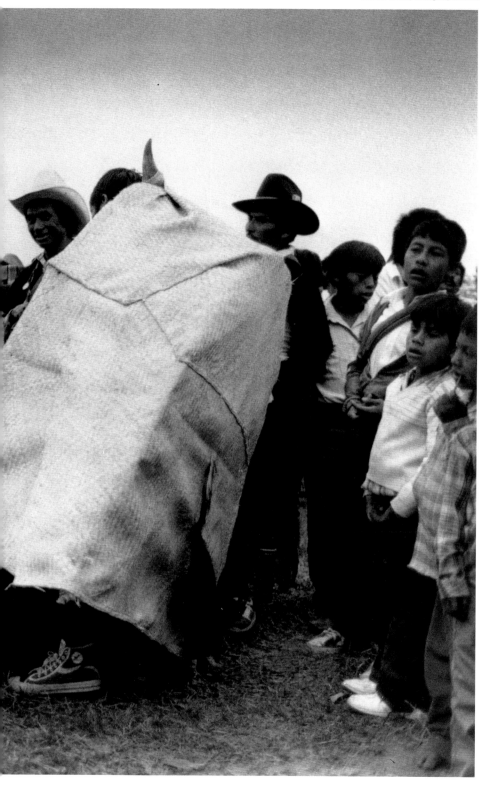

HEADING NORTH » The Mixtecos

Eniac Martinez

Work documents of Mixtec workers in the United States

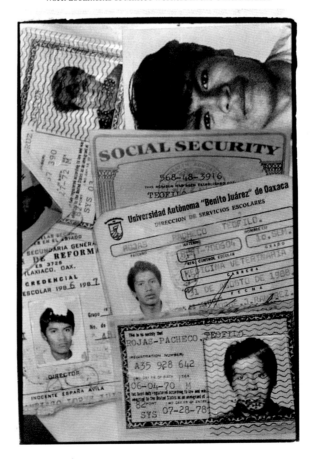

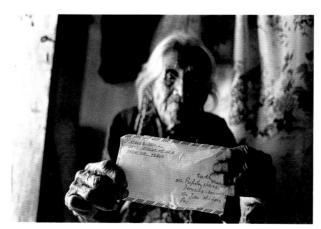
Senora Perfecta Chavez at home in San Juan Mixtepec, Oaxaca,
receives a letter from her son from the United States

Since the deepening of Mexico's economic crisis in the early 1980s, indigenous peasants from the state of Oaxaca have illegally entered the US in increasing numbers, contributing to a dramatic rise in the relative importance of new sending regions [areas of high immigration] in the US-bound Mexican migration stream. These new migrants are among the most impoverished workers in the United States today. Mixtec and Zapotec Oaxacans have been found living in caves, under bridges, and earning 60-70 per cent of the minimum wage. Our best estimates suggest that 15,000-50,000 migrants from Oaxaca are working in California agriculture; however, their numbers will continue to rise as conditions in both Oaxaca and California favor increasing migration.

Compared with the Mexican migrants from the traditional sending regions of Mexico, who generally have much more collective experience adapting to life in California, the new indigenous migrants from Oaxaca are arriving with greater handicaps: many speak little or no Spanish (much less English); they are in more desperate economic circumstances; many are undocumented [without papers]; and they are subject to racism even from other Mexican-born workers, because of their distinctive culture, language, and appearance.

Oaxaca is one of the poorest states in the Mexican republic and has been especially hard hit in a national crisis that has cut average real wages in half since 1982. Since the late 1970s, migrants from Oaxaca have become an important labor force for the growing number of vegetable exporters that produce in the northern Mexican states of Sinaloa and Baja California. The workers in these labor markets are subject to extremely poor working conditions, characterized by lack of protection against hazardous chemicals, extremely low wages, and abusive patron-client labor relations.

The migrant stream from Oaxaca to Sinaloa and Baja California has been moving north into the United States in the last five to ten years. The incorporation of Oaxacans into the California farm labor market has occurred principally via farm labor contractors, some of whom operate as coyotes, facilitating illegal border crossings. For those familiar with the conditions that farm workers live under in the fields of northern Mexico, the Oaxacans are easy targets for perpetuation and replication of the abusive labor relations south of the border.

Ironically, the migration experience seems to be strengthening the Oaxacan migrants' ethnic identity, contradicting conventional theories which hold that cultural distinctiveness is attenuated as a result of migration. Their shared culture is providing a basis for social cohesion in the trans-national context, and has led to the formation of important self-help organizations in California. Like the Asian immigrants before them, the Oaxacans may be able to use these cultural resources to improve their situation and eventually find a niche in other sectors of the economy. However, their efforts are still in a very incipient stage and little is known about their successes or the obstacles they face.

**Indigenous Oaxacan Migrants in California Agriculture:
A New Cycle of Poverty**
Co-principal investigators: Carol Zabin, Michael Kearney,
Carole Nagengaso, Stefane Varese

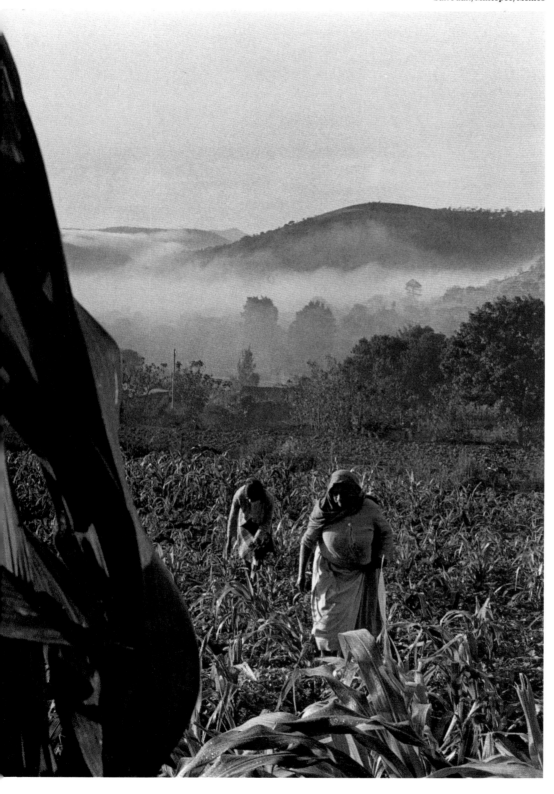

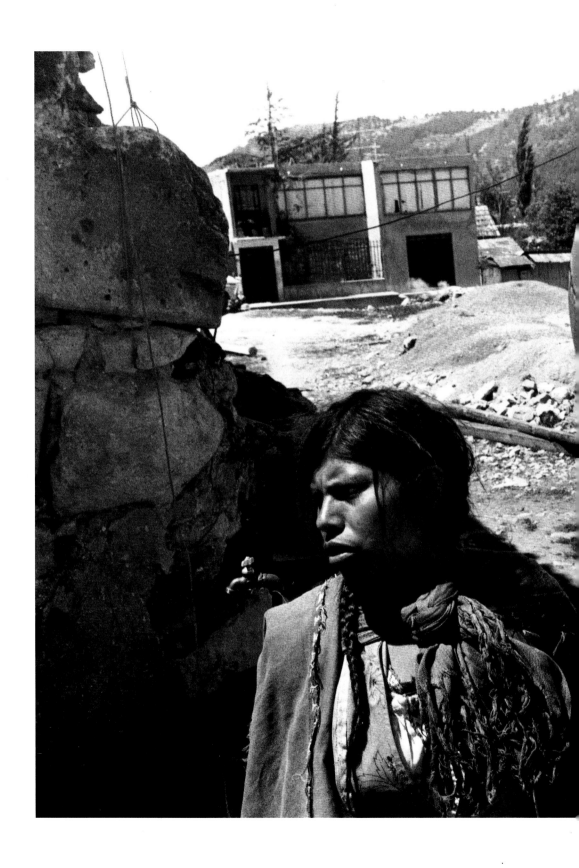

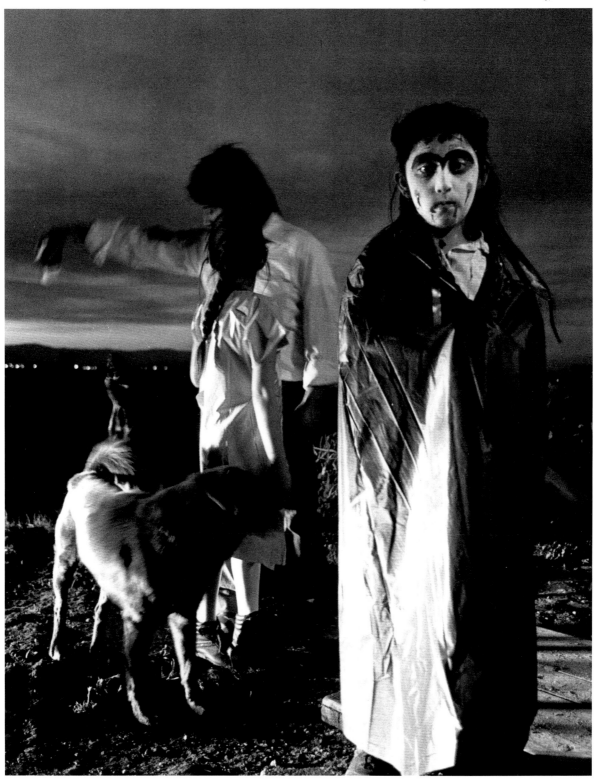

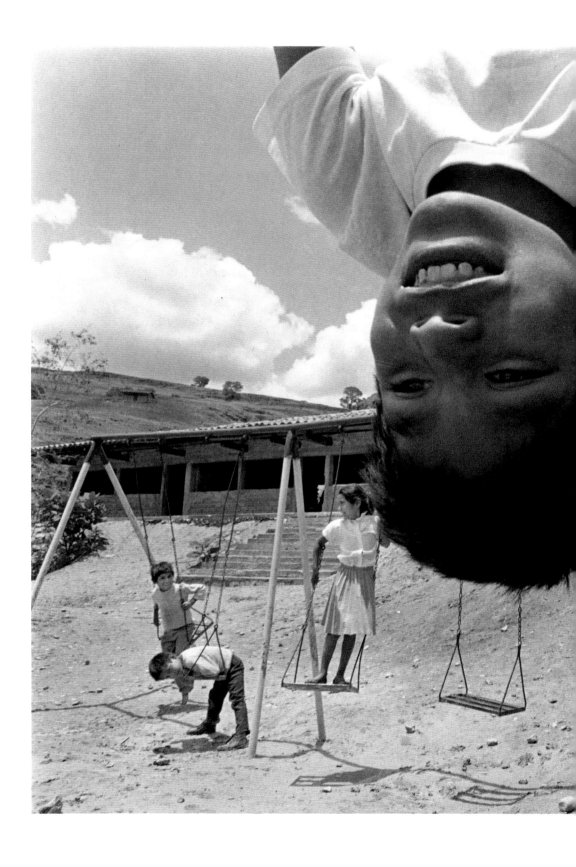

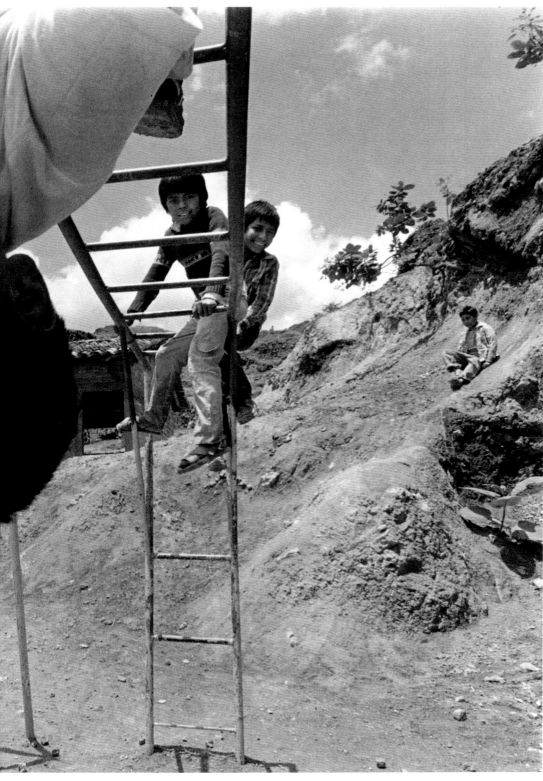

INSIDE the USA

Pedro Meyer

Only ten years away from the twenty-first century, and our neighbor to the north is the most powerful country, both in military and economic terms, a nation as rich in contradictions as it is wealthy in material things. In the absence of a strong cultural tradition of its own, it needs to reinvent itself at the turn of each new day. The influence and presence of this 'great' neighbor of ours can be found and experienced at every corner on earth; way beyond any possible merits that their values or commodities could have. An explanation for this magnetism is quite difficult at best, as for every 'good' reason one can find, there is an exception which can prove the opposite; one could almost state, without fear of exaggeration, that there are no real limits to such arguments. The mathematical combinations of the Rubic cube pale in comparison. A Mickey Mouse, is a Mickey Mouse, is a Mickey Mouse.

The ideals of the American Way of Life as an exportable ideology have gone the route of the great

Tombstone, Arizona, USA

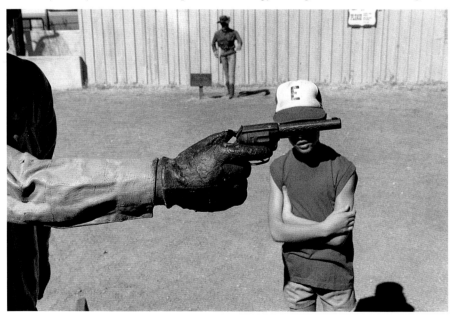

photo-essays in *Life* magazine of the 1950s: a great mystification. I wouldn't be surprised if the United States with all of its might were in the end to become a net importer of the Third World Way of Life, rather than following its original script.

We are told by *The Economist* (January, 1990) that, in 1990, 'the life expectancy of men in Harlem, the black and Hispanic quarter of Manhattan, is even lower than in Bangladesh'.

All of these elements have their obvious impact on the reality of my own country, Mexico. The dynamics generated by sharing the largest border anywhere between the First and Third Worlds make it imperative that we look in detail at the inner workings of our neighbor, more than passing judgement, something almost inevitable, one also has to learn in order to give adequate meaning to that which is observed.

The fact that photographs are capable of expressing simultaneous realities, in which the observer determines through his or her own perception that which is supposedly the essence of the matter, seems to make them a very appropriate medium to approach this almost unfathomable subject: the US.

A photographic image represents at the same time those elements of its own likeness, as well as the 'house of mirrors' concept, which after all is so prevalent in US culture. What you see is not really what you think you are seeing.

The Americans (by the way we Mexicans could also be considered Americans – as both our countries belong to the American continent – only that the *gringos* unilaterally appropriated for themselves the name of an entire continent) perfected the animated cartoon, film, television, and all contemporary forms of the image to such an extent that many people today have a difficult time distinguishing fact from fiction. Probably that's the way they wanted it anyway.

As one observes images about the US one could, in many ways, also relate them to our Mexican reality. There are inevitable echoes and resonances given off by our mutual proximity.

The syncretism of the Spanish conqueror's Catholicism and the religion of the pre-Hispanic Indians created much of the cultural values present throughout contemporary Mexico. Many times the Indians would place their gods either behind or alongside their adopted (by imposition) Catholic altars so as to worship them in spite of official regulations prohibiting this; the priests in turn (or those in power) would manipulate and use such situations in order to establish their control and power over the Indians.

Those altars of yesteryear have been replaced today by modern versions: televisions; and just as the Indians located their gods (idols) on or next to

altars, modern surrogates for such idols are also to be found on the present-day pulpit: the television set. The present forms of idols are, curiously enough, also called 'idols' and they come from the world of entertainment (rock musicians, movie stars, athletes, singers, tele-evangelists, etc.) and, as in the past, they are also sought out for emotional guidance and inspiration.

Just as our priests in the past manipulated, alternately, a degree of tolerance or suppression of Indian deities, in quite sophisticated ways, so as to gain acceptance and credibility to save 'souls', their contemporary 'politicians' or 'leaders' are also in search of 'souls' (votes) as well as control, and to that end manipulate their own images with the strong support of the entertainment industry (the present source of idols). The former chain of church-priests-altars-idols-indians has been replaced by the modern combination of government-politicians-television-entertainers-citizens.

Today, it's the syncretism of politics and entertainment, with most of the countries in the world tuned in . . . looking towards the US and learning from them.

Let's review a very recent 'spectacle' well orchestrated by the entertainment industry in the US (today, even the news is handled as entertainment): the invasion of Panama. They even came up with a well-thought-out theme: 'Operation Just Cause'.

What could be more 'just' than another invasion of one of our nations with that splendid desire to install 'democracy' (can one *install* democracy?). So the first thing they did was to prop up yet another one of their puppet governments (the last one really soured on them).

We – the world – have even had the outstanding break of seeing for ourselves on television just how grateful the 'entire' Panamanian population has been (with television images proving the veracity of this); too bad they only interviewed upper-class, white, fluent-in-English housewives (maybe they were even the wives of American soldiers stationed there), because the *majority* of poor, darker-skinned, Spanish-speaking Panamanians never merited either a body count of the – what was it? – hundreds or maybe even thousands that were killed by the invading forces happily bombing their way through entire low-income neighborhoods, or their inclusion in any 'opinion' polls about their bombed-out homes and shops: there were so few of them left anyway that they were obviously hard to find.

The rest is entertainment and politics as usual, only that it's getting harder and harder and harder to distinguish fact from fiction, and with almost no one really caring.

Pedro Meyer
Coyoacán, México D.F. January 1990

Computer generated images, Pedro Meyer

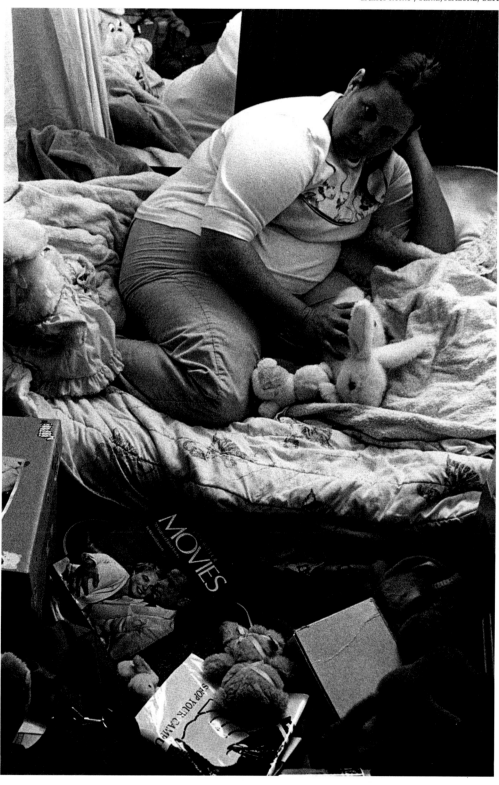

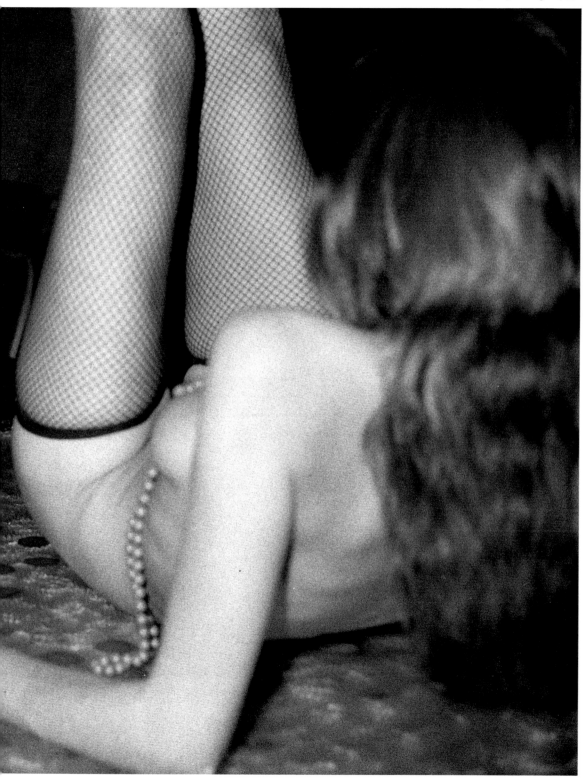

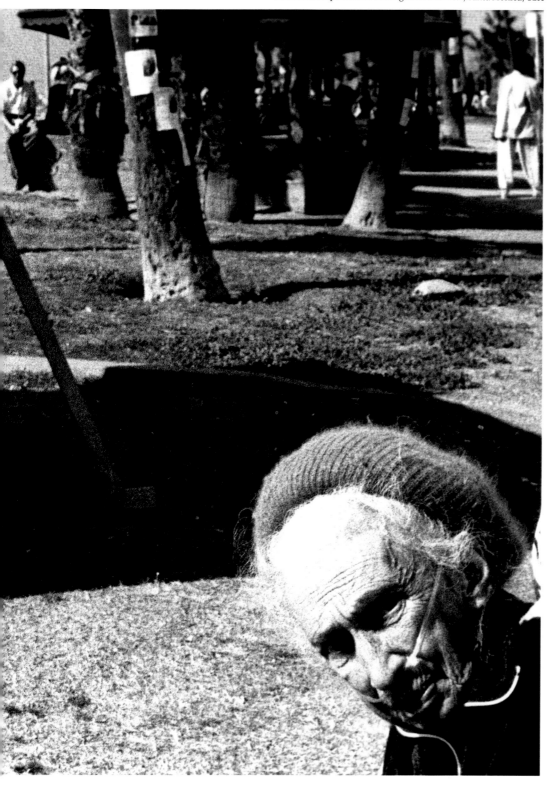

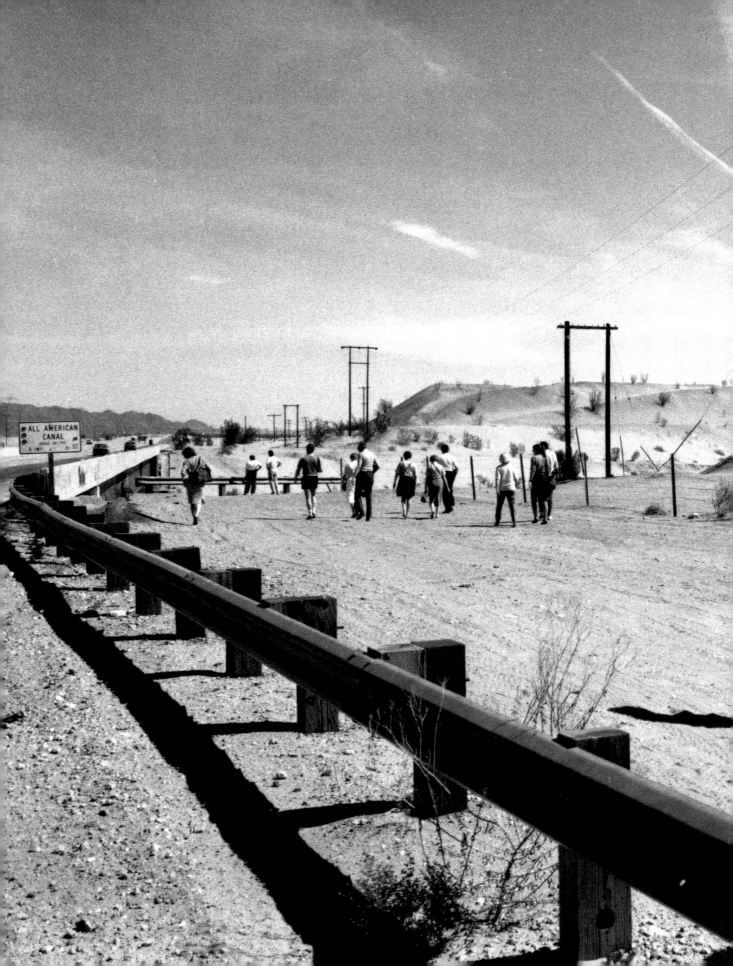

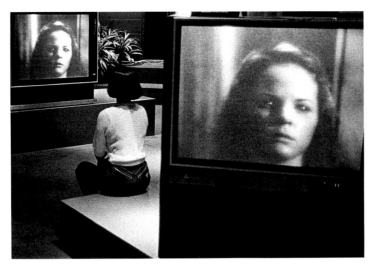

'Satanic Curses', New York, USA

'All-American Canal', Yuma, Arizona, USA (*previous page*)

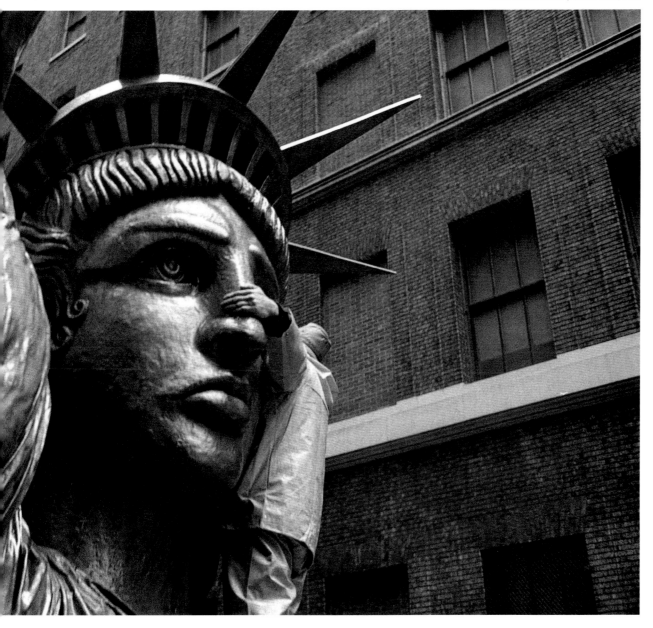

'In Search of Liberty', New York, USA

'LAND and FREEDOM'

Adrian Bodek

Maria Transito Bueno viuda de Robles, 90 years old, Cuantla, Morelos, Mexico

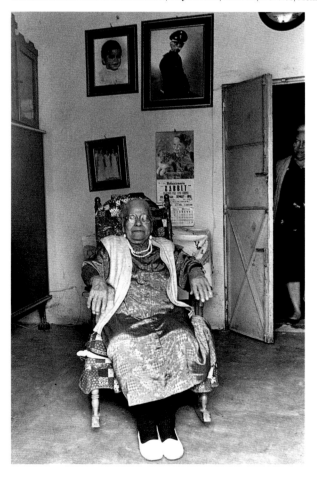

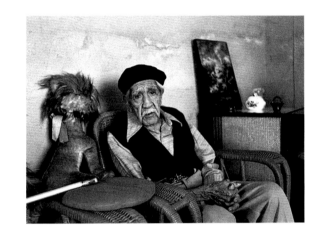

Roman Toscano, 94 years old, Tlayacapan, Morelos, Mexico

'I am a railroad man, rather I was, now I do anything. We the railroad men were the favourites of Zapata, Emiliano's elite. After all, how could a revolution succeed without a railroad.'

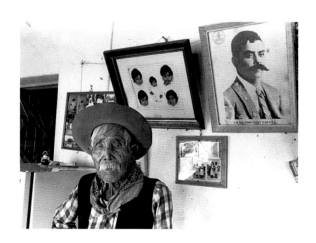

Angel Garcia Ronmero, 96 years old, Cuantla, Morelos, Mexico

'. . . I was loyal to Zapata's party. I suffered under the Spanish in the haciendas. They whipped us with leather thongs, at home my father only scolded me. They treated us like animals. Everyday we would receive four to five lashes of the whip. They wanted to brand us.

'We were like slaves. If it was not for Zapata who knows where would we be . . .?'

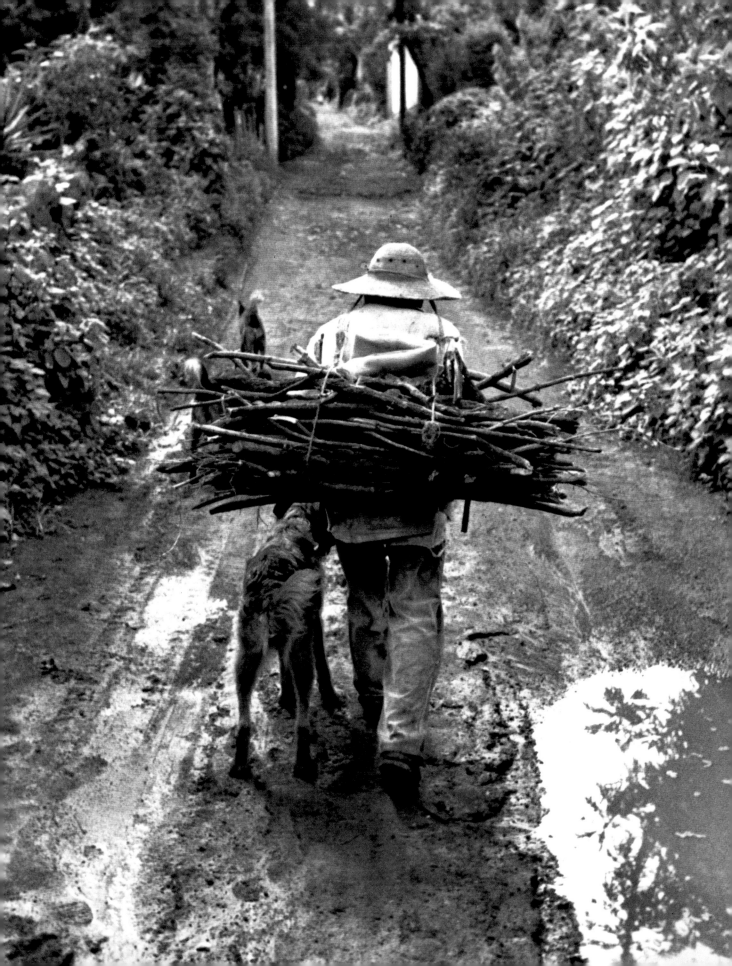

The Zapatistas did not conceive of Mexico as a future to be realized but as a return to origins. The radicalism of the Mexican Revolution consisted in its originality, that is, in its return to our roots, the only proper bases for our institutions. When the Zapatistas made the calpulli the basic element in our economic and social structure, they not only salvaged the valid portion of the colonial tradition but also affirmed that any political construction, if it is to be truly productive, must derive from the most ancient, stable and lasting part of our national being: the indigenous past.

Zapata's traditionalism reveals that he had a profound awareness of our history. He was isolated both racially and regionally from the journalists and theorists of the epoch, and this isolation gave him the strength and insight to grasp the simple truth. And the truth of the Revolution was actually very simple: it was the freeing of Mexican reality from the constricting schemes of liberalism and the abuses of the conservatives and neo-conservatives.

The Zapatista movement was a return to our most ancient and permanent tradition.

Octavio Paz • **The Labyrinth of Solitude**

Chanito Vidal, 91 years old, Tepoztlan, Morelos, Mexico

'Tierra y Libertad' Emiliano Zapata

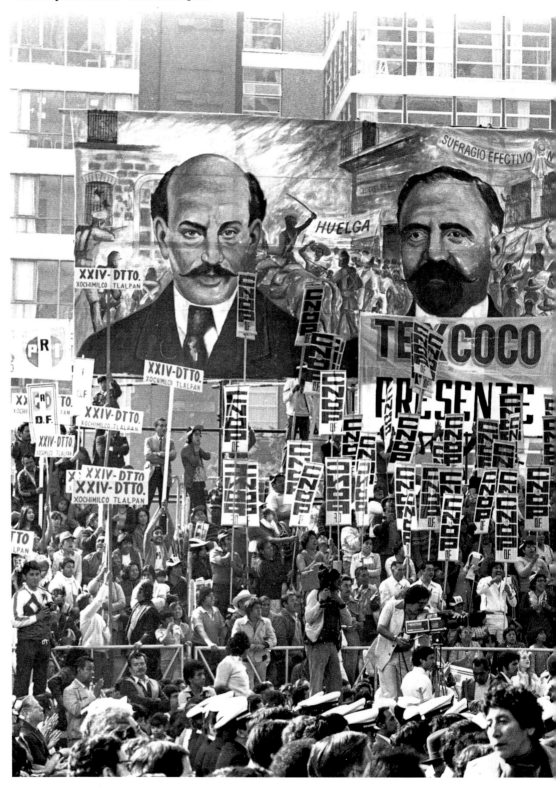

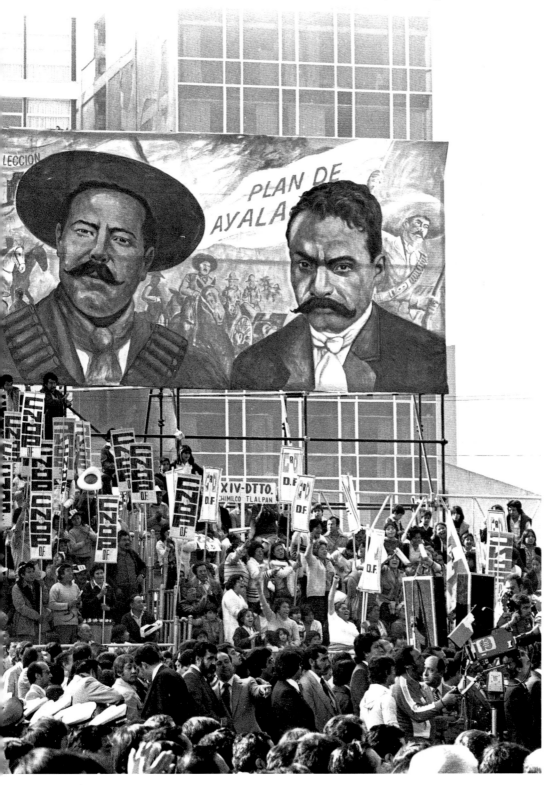

MIGRANT WORKERS » Guatemaltecos

Marco Antonio Cruz

Family arriving from San Marcos, Guatemala, at the hacienda of
Finca la Patria, exhausted after a three-day walk, Chiapas, Mexico

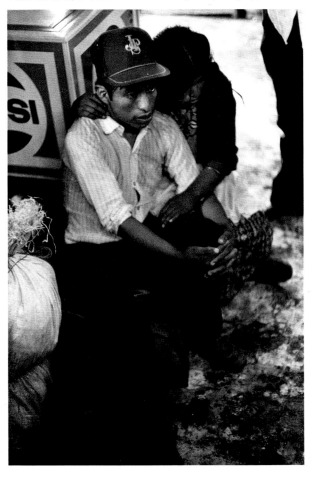

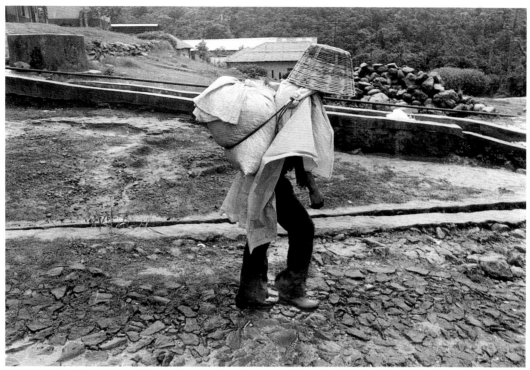

Coffee worker returns from a day of picking beans, *Finca la Patria*

In the Mexican state of Chiapas, on the Guatemalan border, in a place known as Soconosco, there are about 50 coffee plantations. These ranches were established by the Germans in the 1930s and 1940s. Today they belong to their descendants, and some are managed from West Germany.

The area of each plantation varies between 20 and 60 hectares. The coffee production rate in these ranches is high, the coffee is of good quality, and most is exported. The majority of the *campasinas* needed to maintain the plantations come from Guatemala; few are Mexican.

From October to February each year, during the harvest season, about 60,000 peasants emigrate north. They come with work permits, obtained by the ranchers from the Mexican government. Most of the workers are from the area of San Marcos in Guatemala. Whole families come to work, old men and women and children. Some of the peasants are hired directly by ranchers on the Mexico- Guatemala border, others have been working for generations on specific ranches. Those who have no contracts walk from San Marcos in Guatemala to the Mexican town of Union Juarez, a journey which takes between two and three days on foot. There they are finally hired and taken to the plantations.

The working conditions for these people are as follows:

Daily meals consist of beans and tortillas, served twice a day. The *campasinas* have to pay extra for these meals.

Living facilities consist of dormitories, collective barracks where workers sleep on wooden boards. Blankets are not provided.

There are no toilet or bathing facilities.

There are no medical facilities; the most common tropical disease is malaria.

There is a shop on the ranch where ranchers sell basic products, such as soap, eggs, sugar, etc. They charge high prices for these goods.

Women and children work the same shifts as the men. Their salaries are the lowest in the country.

Marco Antonio Cruz

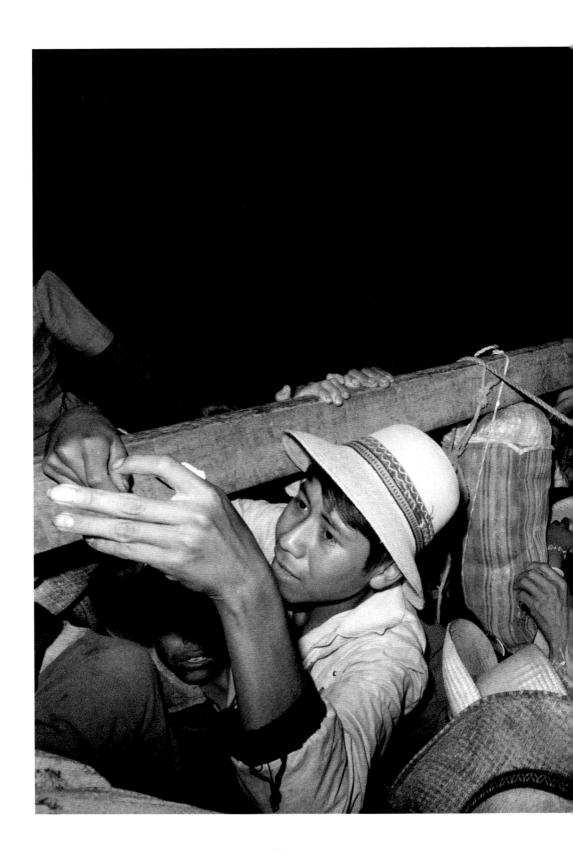

Transportation of Guatemalan *compasinos* from Union Juarez on the Mexican border to the coffee haciendas in Chiapas, Mexico

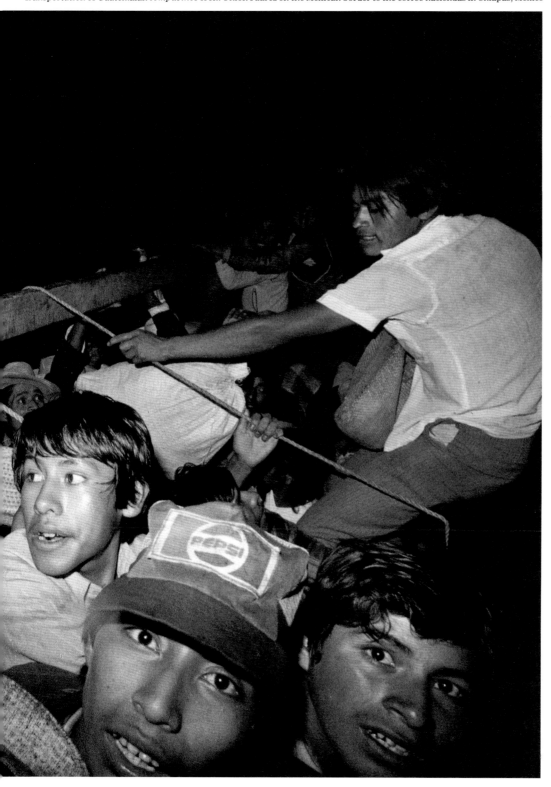

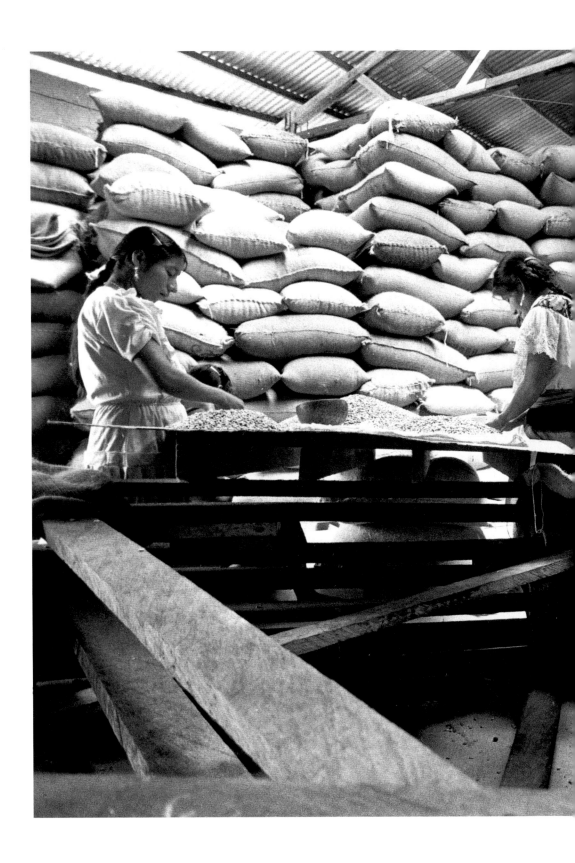

Living quarters for the workers on the hacienda consist of large shared dormitories, Chiapas, Mexico *(over)*

Women sorting the coffee beans for export, at the *Finca la Patria*, hacienda, Chiapas, Mexico

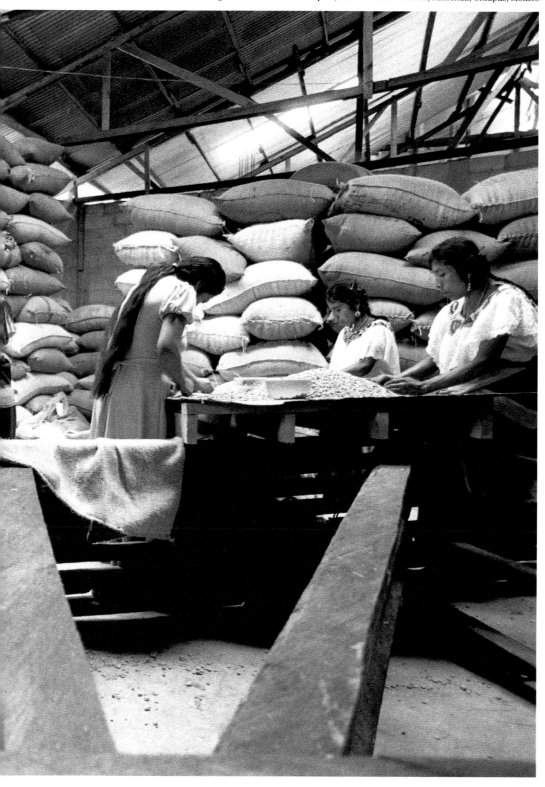

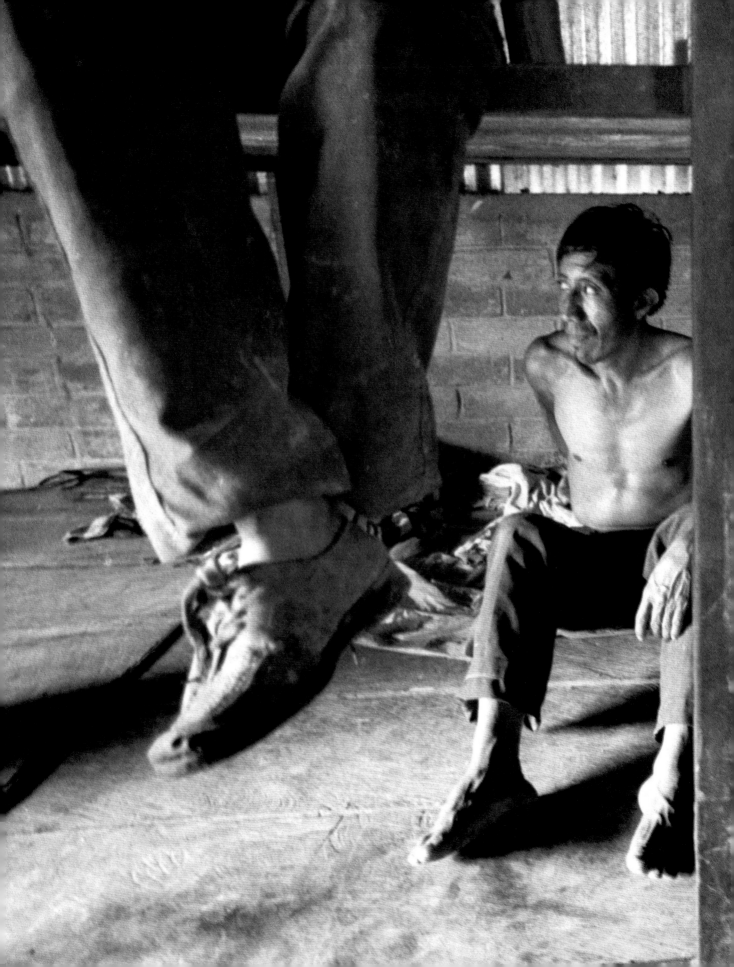

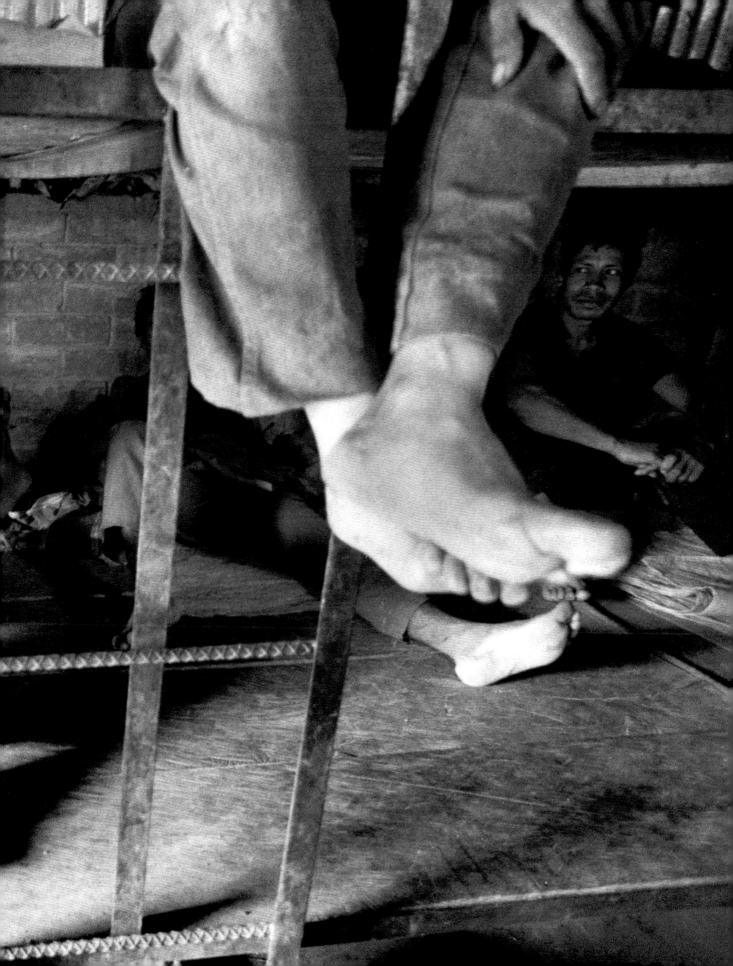

MAZAHUA

Mariana Yampolsky

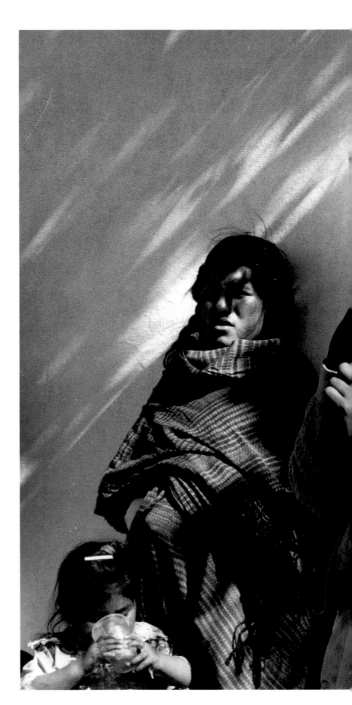

'We are the Mazahua women. Long ago we owned deer, now we don't even have men. They have all gone to work on building sites in the big cities; they are labourers there. They come home once a month but after a while they don't come back at all. We never see them again. We do the ploughing, plant the seeds, harvest the maize. The land is dry and poor, dust storms whirl around us.

'Our pleasure is the maize. When it bursts into flowers, it explodes into whiteness, like the snow on the peak of the Nevado de Toluca. With popcorn chains we adorn the saints. We cover them with maize flowers.'

Elena Poniatowska

72

Women of the Maguey, Estado de Mexico

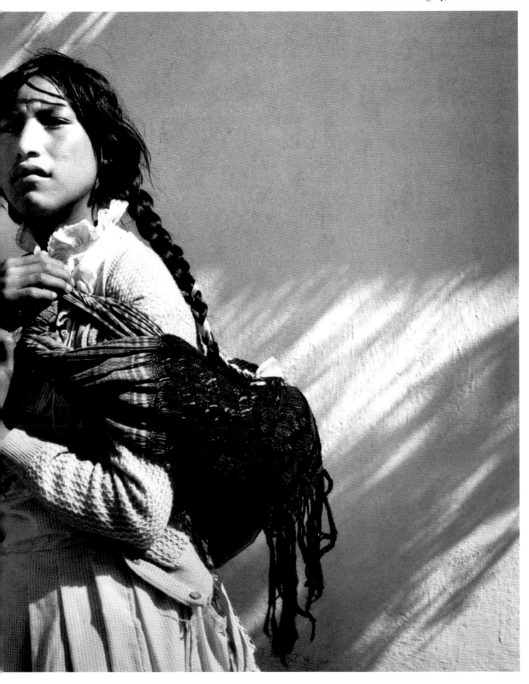

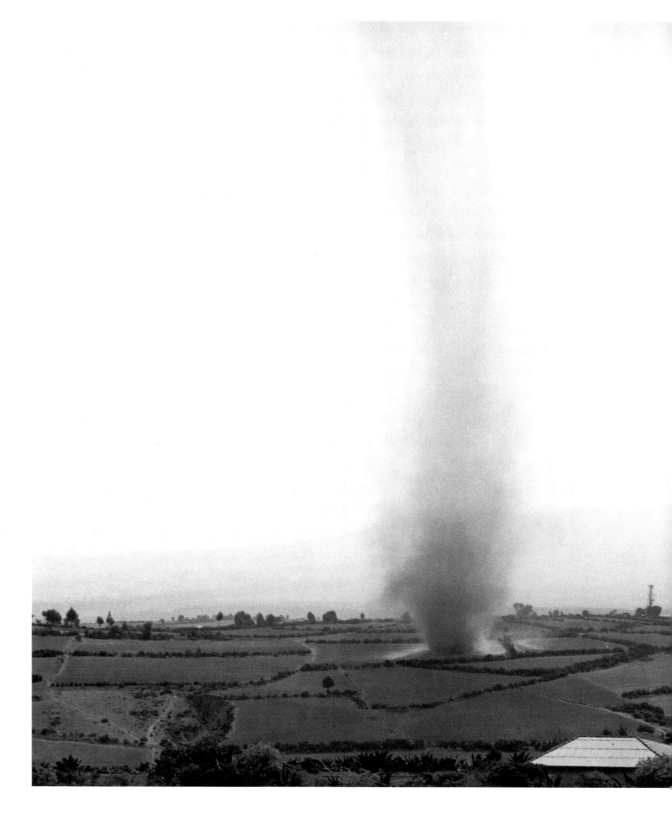

Dust Storm, Estado de Mexico

COUNTRY WOMEN

'. . . Blessed are thou among women.'

Within the yellow chapel with its light green
tower in 'Ojo de Agua' near the Peak of Orizaba,
Miguelina Montiel says her rosary. Miguelina doesn't
go every day, only when her four children, Julia,
Tirso, Elisa and Minerva, do not need her. As she
prays she goes over her day since dawn.

'. . . The Lord is with thee.'

At five in the morning she handed the mug of hot
coffee to Camerino who was warming himself close
to the fire. Later, he would lead the cow to pasture,
tie her up and milk her. Miguelina took two kilos of
corn and hurried to the mill. Smoke seeped out of the
houses into the cool air. Her feet sank into the moist
earth. She wound her way around the wooden
houses, crossed the fields and saw the queue of
women already waiting at the mill to grind their
corn. Some women take yellow corn, others white,
others blue, and every so often, the miller has to turn
over the stone because it wears down from so much
grinding. With her dough in a pail, Miguelina hurried
home.

'. . . and blessed be the fruit of thy womb.'

In the kitchen she had left the fire under the
'comal'. The patting of her hands like quiet applause
echoed in the air, racing against time. The fire
mustn't die down. The daughters get ready for
school. Before they leave, it is their duty to go to
the well and bring back two buckets of water each.
When they finish combing their hair, such a rush!
such a clatter! and then silence. Tirso, the son, helps
in the fields and Miguelina must bring them their
meal at noon.

'. . . full of grace.'

Before one, Miguelina stacks her clay jugs. Soup, rice, beans, tortillas and lemonade. If she walks quickly she will get to the field in half an hour, if she doesn't it takes an hour. Who is going to dawdle when the sun is so hot? The three of them eat in silence under the shade of a tree.

'. . . Holy Mary, Mother of God.'

At home the children help themselves. The house has two rooms; one in which they all sleep, the other where they eat. The toilet is outdoors and Minerva, the baby, was always afraid to fall in the black hole. When it smells too strongly, lime is thrown over it and another hole is dug further away. After all, there is a lot of land.

The corn is kept on the roof along with the potatoes, the beans and the peas. When the weather is extreme, there are no crops and Camerino gets worried.

'. . . deliver us from evil.'

It's wearisome to beat the dirty clothes on the washing stone. It weighs so much and the water is cold. It's a long way to the banks of the river that flows from the peak of Orizaba. When the river is high no one bathes after washing clothes because the current is so strong. Jesusa, who paid no attention or perhaps was too tired, was pulled into the water with her black hair unbraided whirling with foam. They found her far away where the rivers become calmer. The women took her *burro* home without anything on its back. Everything was lost, even the clothes.

'. . . pray for us sinners.'

In Mexico, 52 per cent of the total population of 85 million are women. The majority earn less than ten dollars a day and country women don't earn anything. When her children were infants, Miguelina toiled one hundred hours a week, with no time to say rosaries in church. She can't remember one single day without work.

The Montiels are rich because they own a cow, a piece of land, some chickens, a cat and a dog, a wooden and tin house, a mobile toilet and they live in a green valley that smells of orange blossoms.

'. . . here is the slave of the Lord.'

Some day soon the girls will probably leave for the city, not to Huatusco, nor to Puebla, but to Mexico City to work as servants. After a while, with luck, they can bring home a television. People say that soon we will have electric light, also drinking water. Why do we need it if it comes clear and cool from the peak of Orizaba?

Perhaps with a lot of luck my girls will become secretaries, nurses or telephone operators. It's a question of destiny, the Virgin of Guadalupe or Our Lord Saviour Jesus Christ, God Almighty will provide.

'. . . now and at the hour of death, amen.'

Miguelina pulled her *rebozo* over her head, lost in thought. She knew that the rosary was coming to an end. On the altar, the Calla lilies were wilted. She thought of her daughters; they would soon go to the capital, her son too. Young people swear they will come back, but if they do, it's only to leave again. Here, in Ojo de Agua, my old man and I will remain, she thought. Life is very hard and who will give us the gift of our daily bread?

Elena Poniatowska

Translation: Mariana Yampolsky

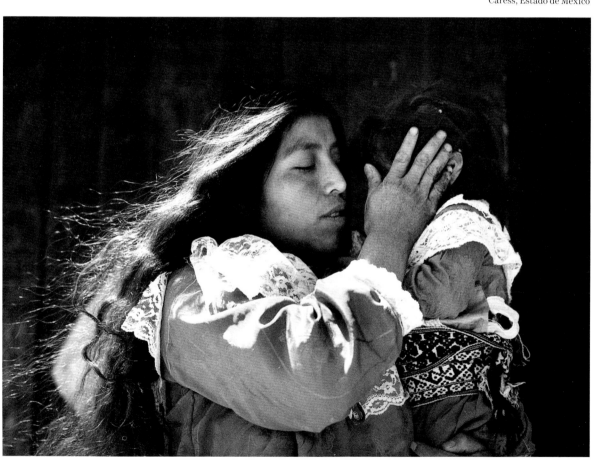

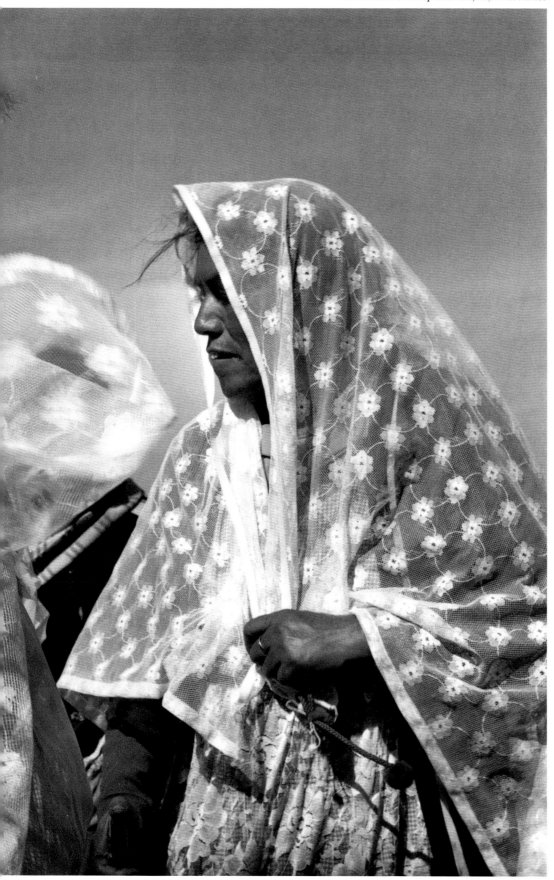

MUJERES »Place of Dreams

Alicia Ahumada

and she comes shining, loosed from what is useless
to my soul;
she changes
like the flame, or like the time
in herself, to what was hers. She lets fall
away from her such lonely, dark
ruins of cinders and cities

Ruben Bonifaz Nuño
LA FLAMA EN EL ESPEJO

Bedspread with wings, Valley of Mezquital, Hidalgo, Mexico

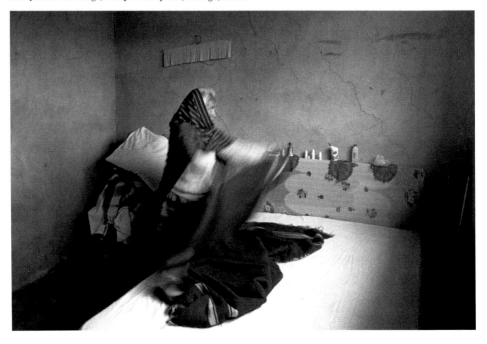

Grandmother and child, Agucatlan, Hidalgo, Mexico *(over)*

Place of dreams, Pachuca, Hidalgo, Mexico

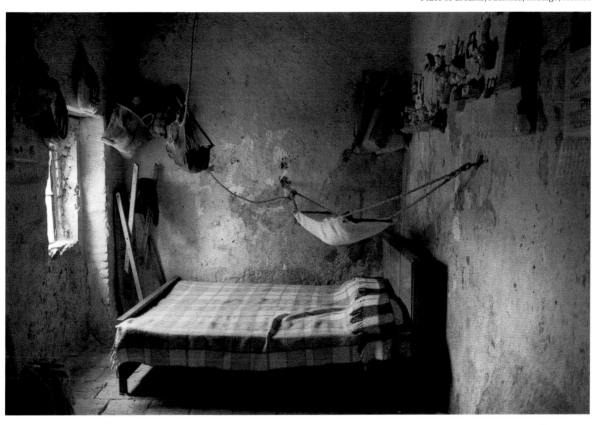

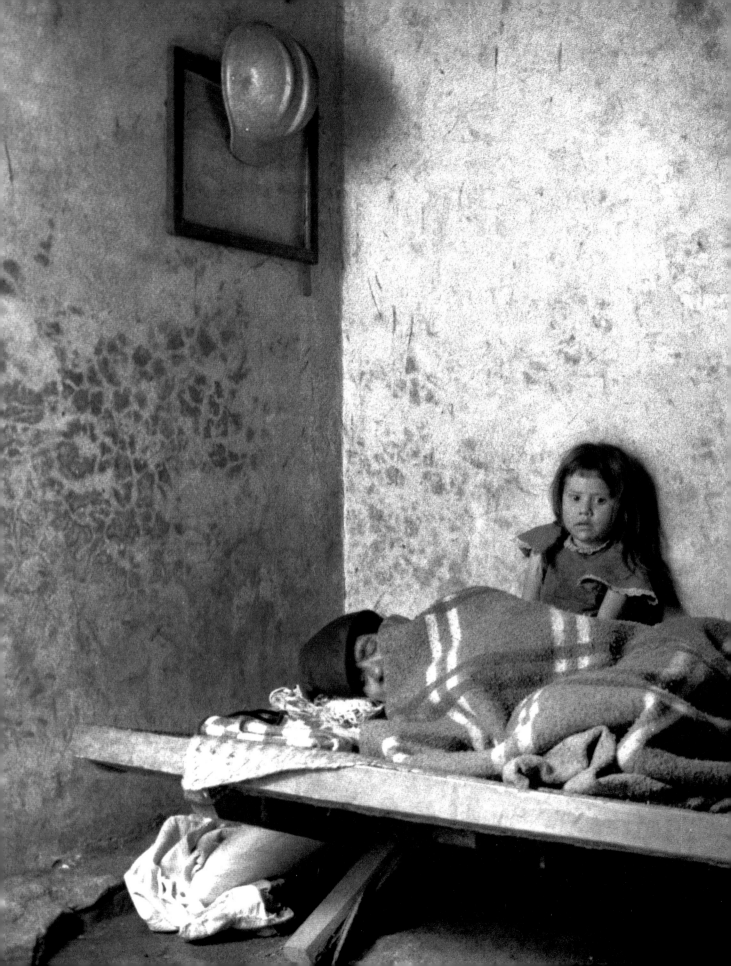

EYES of GLOOMY STONE » The Blind

Jose Hernandez Claire

Eye operation, Chiapas, Mexico

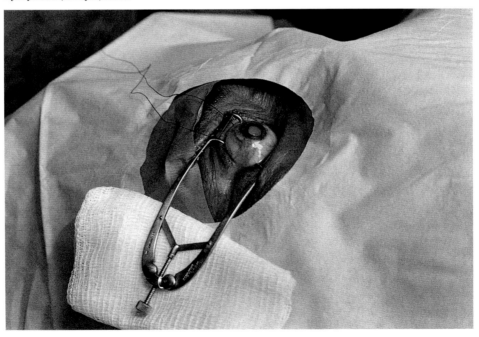

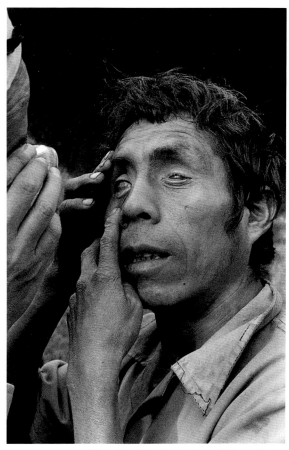

Manuelito visits the eye doctor, Chiapas, Mexico

IXTEPETLA: EYES OF GLOOMY STONE

Nahuatl medicine was one of the most advanced medicines of its time, based on a vast collection of historic herbal remedies. Cures took several forms: medicines, teas, plasters, enemas, poultices, and curative meals. People were anaesthetized, cauterized and drugged. Psychological therapy, *Shamanism*[1], and witchcraft, were also practised, sometimes with remarkable results. Surgery was also attempted using improvised instruments.

A frequent ailment was blindness from cataracts. This was called *n'ixtotolcuii*. When blindness was caused by infection, it was called *ixtemalini'n*. When there was no cure for any of these illnesses, the patient would then become *ixteptla* (totally blind) as a result. The Aztecs interpreted this literally as 'being with the eyes of gloomy stone'.

Blindness was a curable disease before the time of Cuauhtémoc's Mexico.[2] When it was a case of curing infections, herbs with magic powers were used. When it was a cataract case *(n'ixtotoliculii)*, surgery was performed with a *huitztlahuatzin* (a porcupine needle) or the spike from a *pitayo* fruit.[3] This operation required the cataract to be 'mature' and demanded a highly skilled medicine-man. Until a few years ago, this operation was performed by Mixtec medicine-men in Oaxaca.

When the operation was successful, the patient was *pilixtli notechca* meaning, the old man with the clear sight of a child. If, on the contrary, the eye became sick and infected in a hopeless way, the *nixcaxiui* was performed: the removal of the eye with an obsidian blade.

In the British Museum there is a skull of a blind pre-Cuauhtémoc man. It is covered with lignite and turquoises. The blind ocular globes, the *ixtepetla* (the eyes of gloomy stone), are made of pyrites. The existence of this skull gives an almost exact idea of the Nahuatl term. It is quite likely that this skull is part of a nocturnal solar rite for *Mictlantecutli* (the lord of Hell: *Mictlan*), where the dead go.

Tlaloc, the god of fertile rain, is represented as being blind, with two empty ocular circles. A blind god dependent on his twin *Ehécatl*, meaning wind, the twin brother gods, rain and wind. As it is said, *Ehécatl*, the wind, comes before the rain, *Tlaloc*. The wind god guides his twin brother, god of the rain. It is *Quetzalcoatl – Ehécatl*'s will – that takes *Tlaloc* and his clouds to the places where the *tlaloques*[4] pour their jars over the fields to wet them with fertile water.

Augusto Orea Marin

Translation: Ana Maria Linares

Translator's Notes:

1. Shamanism: ritual performed by a shaman (witch of a tribe). Also the beliefs and practices related to this character and his powers.
2. Before Cuauhtémoc: the author uses this term as a synonym for pre-Hispanic. It refers to the period prior to the arrival of Cuauhtémoc (1495?-1525), who was the last Aztec emperor.
3. *Pitayo* fruit: a juicy small reddish fruit from a cactus with a thick spiky skin.
4. *Tlaloques:* servants to the rain god *Tlaloc*, who pour the rain from the jars when he gives the order.

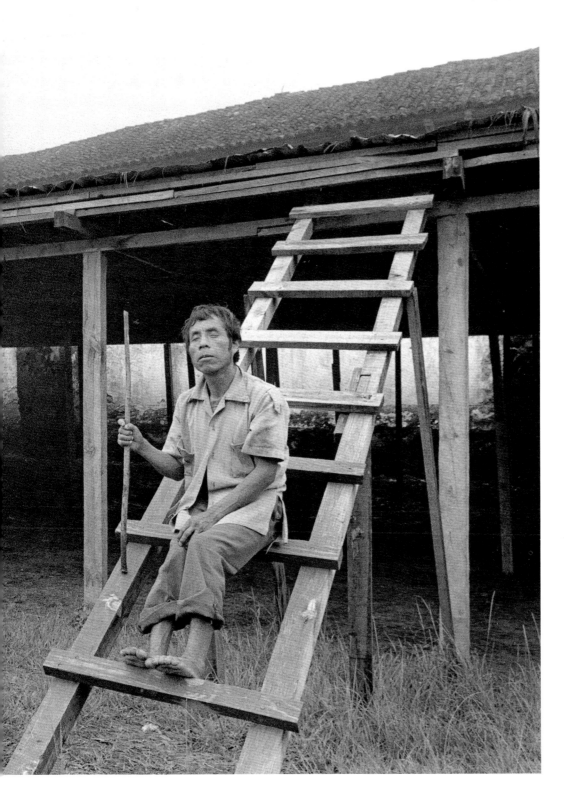

MEGALOPOLIS » Images of the City

Yolanda Andrade Pablo Cabado Marco Antonio Cruz Victor Flores Olea Fabrizio Leon Diez
Pedro Meyer Francisco Mata Rosas Pablo Ortiz Monasterio

IMAGES OF THE CITY

In thirty years (1950-80), the capital of Mexico ceases to be a reasonably organized city and is transformed into a megalopolis. In ten years (1980-90), this megalopolis becomes a typical prefiguration of the Apocalypse, (or a receding Apocalypse, depending on the optimism or pessimism of the inhabitants and commentators). What was authentic disappears or turns into an object for museums. What is typical is progressively Americanized. Violence is seen as 'normal'. Each person pays a heavy price for receiving the advantages of centralization.

Five or six hundred people arrive daily in the Federal District and they will not leave. Immigrants from all over the country saturate tenements and rooftop housing, or live with their relatives in tiny little flats only three hours away from their work place, and abandon in one year habits rooted in generations. Promoted by corruption and blessed by demagogy, they integrate, these 'lost cities' (as they are called at the beginning, later dubbed 'popular colonies'), urban overcrowding, places where absences are distinctive: lack of water, of paving, of sewage, of adequate transportation and of minimal cultural stimuli (apart from those provided by the cinema, radio and, above all, television).

Immigrants live where they can, and transform the perspective of the city. Now there are, in a permanent way, at least two cities: the one that everybody builds for themselves, the personal geography of the home, work and places of entertainment, and the other city. A city of anonymity which is the principle for democratization, a city of the endless street market where half a city sells to the rest.

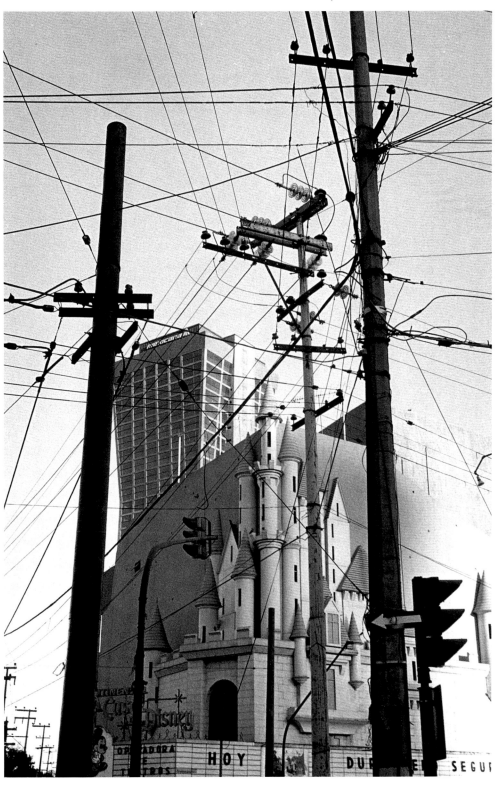

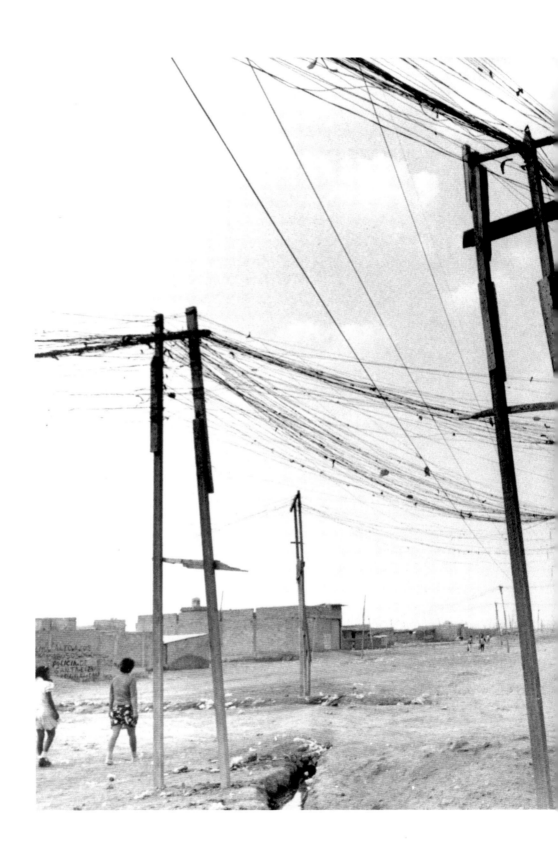

Twenty million inhabitants (a conservative estimate) fight in each underground car the battle for oxygen. They are the non-stop demographic wave that dictates the new law: from now on a semi-abandoned desert landscape will be a place where only one or two hundred thousand people wander, as souls in pain. A demographic explosion, the transformation of Mexico City into the most populated place in the world, is the fact that arranges the flow of images and progressively locates everything else: the *Centro Historico*,[1] pre-Hispanic remains, museums, avenues and monuments used by those in power to broadcast their permanence.

Institutionally, nothing tempts the crowds who invade, consume and define the Federal District to appreciate urban beauty. They have been confined in agglomerations of streets and beds, and in their spare time, cultural pleasures are not a priority. For them, what is important is to own property, any property, and in accordance with this anxiety, they ignore the elegant city that grows to the south, the taste that is polished and becomes cosmopolitan.

The city of the many takes advantage of any available space. For most people it is a necessity to experience 'pretty things' (a popular synonym for beauty), from the most base of feelings. For this reason soap-operas thrive: feelings cost a lot less than objects.

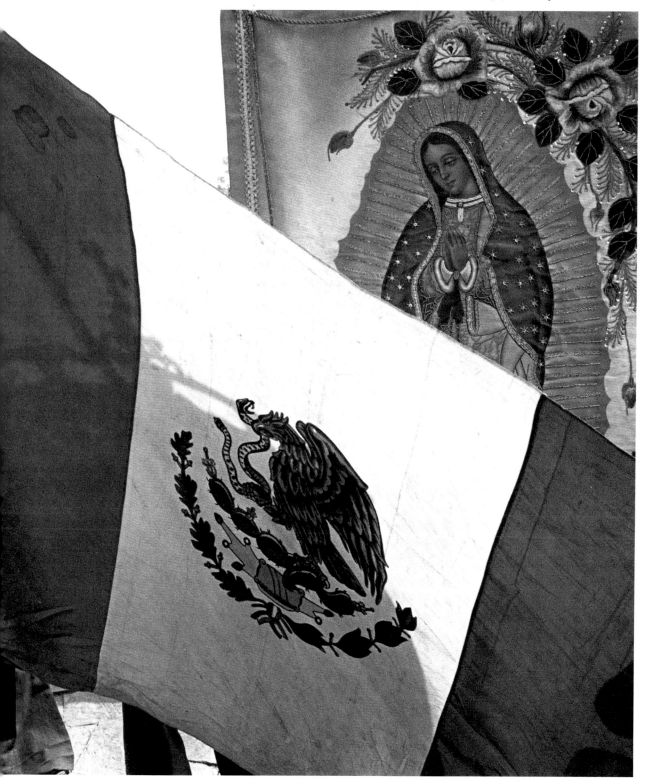

Visually, Mexico City is, above all, too many people. This question can be ignored by taking pictures of desolate dawns, rediscovering the aesthetic vigour in walls and squares, or finding exceptional faces or situations whose strength dissolves any necessity or temptation for anecdotes. But the permanent temptation (the unavoidable theme) is the waiting crowd, the way each person, even without knowing or recognizing it, lives in the splendour of his residence, in accordance with the minimal space that the city dedicates to him. This is the physical, psychological, cultural and visual reality on which images are constructed.

In the 1940s, an extraordinary photographer, Nacho Lopez, shot the city of the poor, and its nightlife, and a new conviction was filtered through his attitude: the city is the greatest show within our reach, a show that includes us and the majestic parade we are resigned to out of habit, but it is about time we joined in, out of admiration. Nacho went through neighbourhoods, streets, night-clubs, billiard halls and circuses, and presented the emergence of modernity, understood as 'the joy of the completely urban'. Later photographers have respected the fundamental part of his findings: Mexico City is a cultural and visual phenomenon whose development dissolves any possibility of *costumbrismo*.[2] It is the energy of each city (which compensates for its being monstrous), which make big urban images different from one another, even if they seem to be the results of inertia. On they go, the crowds have inherited a century of systematic robbery, corruption and economic devastation, and without improving it, they have humanized it in their own way. And to this, the new and excellent urban photography offers testimony.

Carlos Monsivais

Translation: Ana Maria Linares

Translator's Notes:

1. *Centro Historico:* central part of Mexico City where many old buildings and monuments can be seen. It is now a historically protected area.
2. *Costumbrismo:* literary genre of local customs and manners.

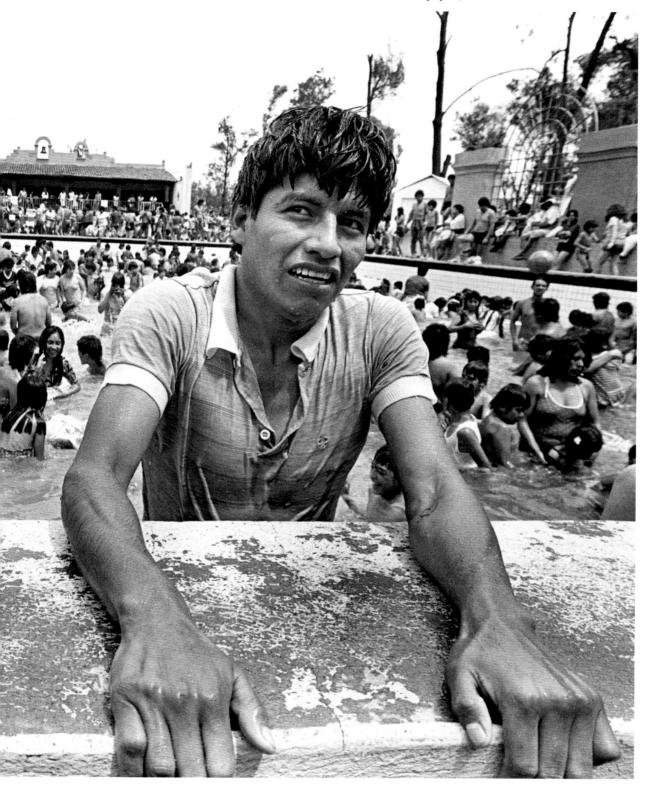

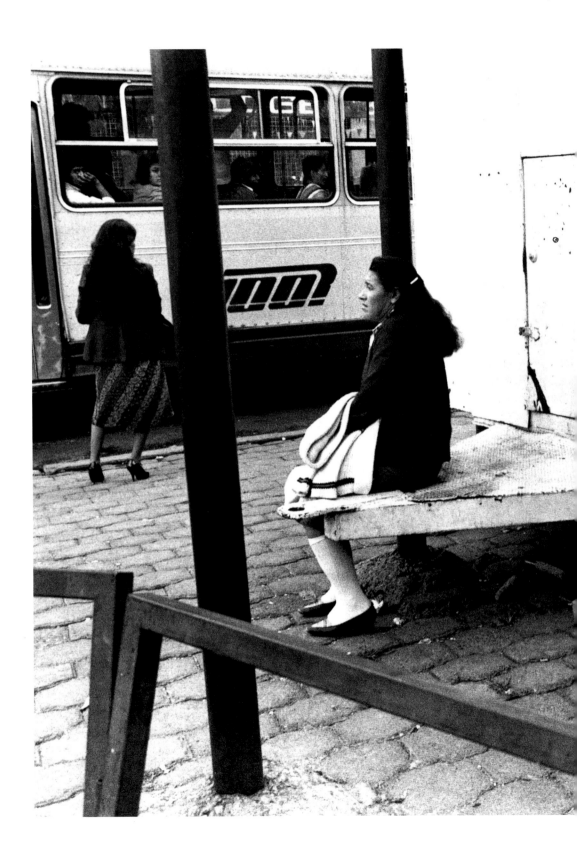

Selling Chicklets ● **Pablo Ortiz Monasterio**

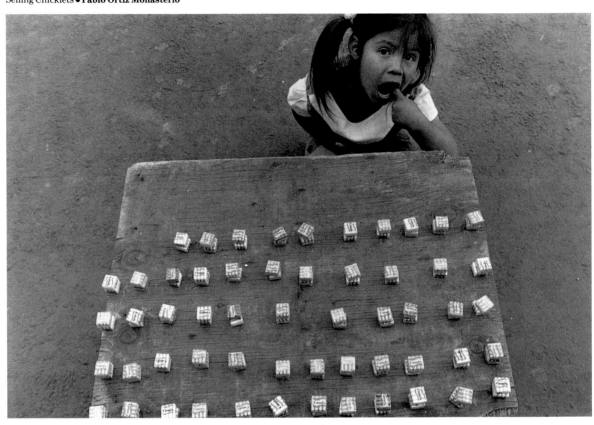

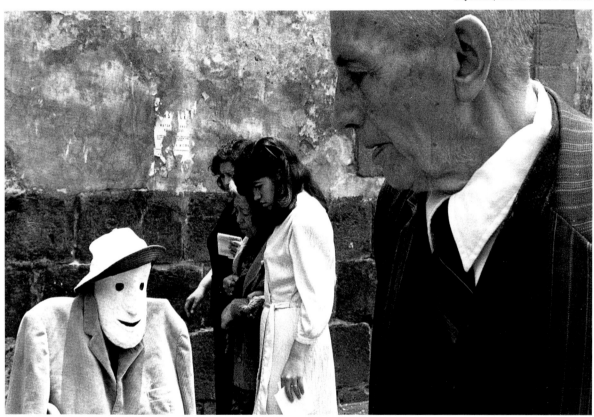

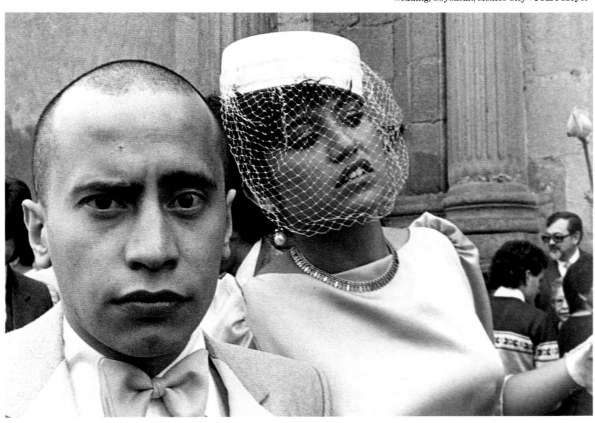

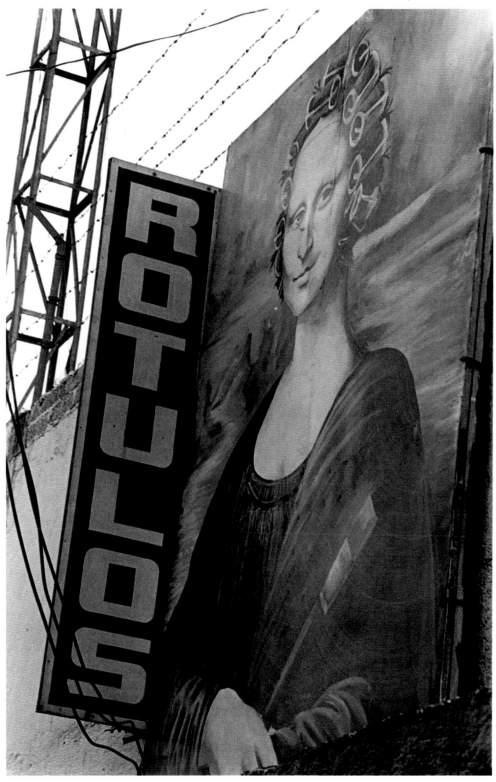

THE MOVING MAP

Two coincidences brought me to the number. The first one occurred on a street near the Great Temple. Workers were digging a ditch; thick trowelfuls of earth fell on to the street. I thought it was some kind of manoeuvre to inject cement into the subsoil and counterbalance the sinking of the city. I watched the workers' task (fairly routine, by the way), until a shovelful of dirt covered my shoes. I stood there amazed: under the dust was an iridescent brilliance. An obsidian arrowhead.

It is not rare to find onyx knives, bits of broken pottery, imperfect tidings of the ancient masters of the high plateau. However, that object which the sun made vibrate in my palm was intact. An arrow never fired? It could be. At any rate, there was something too precise in that triangle of black crystal. More than a military purpose, it seemed to have a symbolic one: an arrow that represents an arrow. Where had it been aimed? I closed my fist before another's covetous gaze discovered my find. Returning home, I had the sensation of having rescued something from the city submerged below our streets. Out of its time, that sign would rest in my pocket like a deactivated crystal – or so I thought.

The second coincidence occurred months later, on the slopes of the Ajusco. I had gone there to see the valley, the rim of mountains, the distinct division between the lapis-lazuli sky and the miasma that covers the city like a lugubrious haze. The buildings were outlined in an irresolute atmosphere.
A conquered city, probably abandoned. Far in the distance, the needle of the Latin American Tower pierced a dark cloud; the Palace of Fine Arts was a curved protuberance; closer, the immense ring of the Aztec Stadium opened like the mausoleum of an unnamed god. By night, the city palpitates like a disorderly and powerful galaxy, but at that moment, I thanked the lava that once spewed from the Ajusco, and I wanted it to pour fourth again. I ignored the recommendation not to drink. At 2,800 metres high, *mezcal* has a different effect, as I proved with the third glass. The cold, together with the agreeable amazement of being surrounded by pines in that mountain refuge where they breed sheep and cultivate flowers for the city immersed in fumes there below, made me ask for a fourth glass. When I arrived at the Chapel of Saint Thomas, I was more

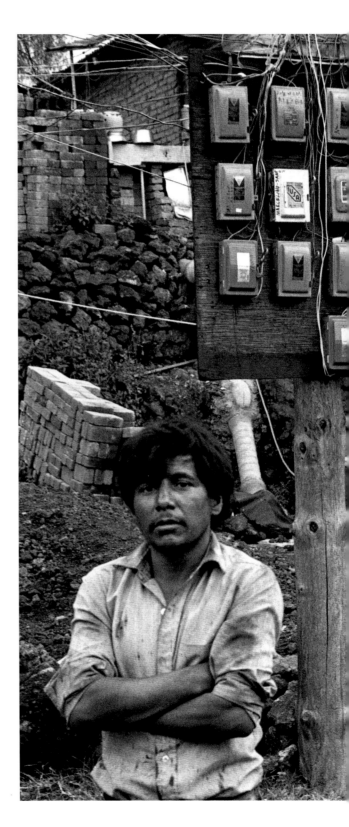

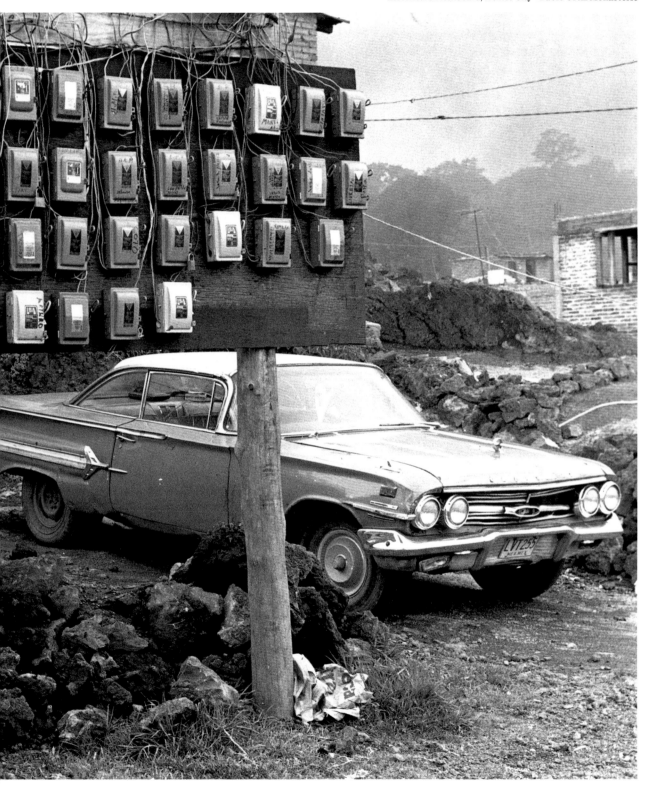

than tipsy. The villagers had made a frontispiece of seeds: the hands of Jesus were made of *garbanzos* (chickpeas) and his hair of corn. I read the inscription carved in the door with a blunt knife: 'to see is to believe'. Destiny asked that I take out my obsidian point. I'd saved it as a good-luck amulet, but it had become a remedy against psychosis. Faced with lifts that never arrive, or interminable queues, a mechanical movement makes me take out the arrowhead. Tense moments that another passes by smoking a cigarette or by playing with his keys, I occupy by stroking my arrowhead. (Sometimes I recognize my uneasiness only after taking out the amulet.) But what happened next had never happened to me before. A calendar salesman, offering a Madonna of six colours or the karate pro, Bruce Lee, hurried towards me. He asked for my number.

'Yes, your number' he repeated. His eyes had a bothersome lustre that I attributed to the inhalation of thinner. In my case, the intoxication of alcohol retarded my reactions. I listened to him for more time than I might have thought necessary on other occasions. The man had an old, smooth face; his wrinkles were hinted at under the skin, as though the thin mountain air kept them in a larva-like state. Around his neck hung emblems: an Indian seed necklace, a scapulary, engraved votive offerings (I distinguished a heart, a crutch, an arm). Perhaps he wanted to add my arrowhead to his collection. The thing was, he spoke a lot, and with great disorder. He mentioned plazas and zip-codes of the city which, at that time, seemed to me fabulously non-existent.

'How many streets are named Zapata?' He smiled with decayed teeth. 'Look for the hammer man. In the cathedral.' His voice was more questioning than authoritative; he gave me an opportunity, he chose me, he included me in his disconnected world. I thanked him, and almost felt relieved to return to the valley, where the first lights of the evening were being lit.

In a few days, the arrowhead, instead of calming me, reminded me of the visit to the mountain. I rubbed it, nervous, trying to erase the haunting statistic: one, two, three thousand Zapata streets. It is obvious that no one knows the city totally. When the taxi drivers listen to an address, they answer,

Coyoacan, Mexico City ● **Victor Flores Olea**

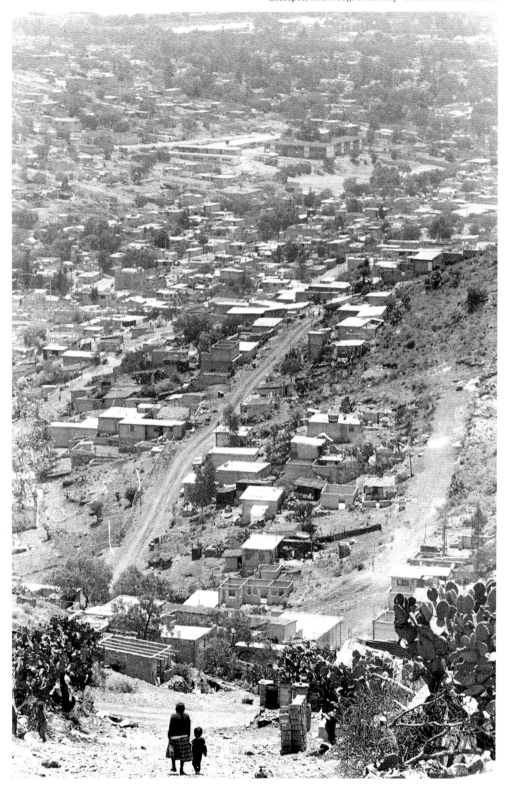

'You tell me which way'. The street names repeat themselves as though there were ten cities superimposed on top of each other. How many are named Zapata? I consulted the *Roji Guide*. There was the answer, shining and cruel: 179. Enough to construct a labyrinth. For curiosity's sake, I looked up others: 215 Juarez Streets, 269 Hidalgos . . . I lost my way in the chaotic geography of repeated heroes. I remembered the second part of the command, but I didn't go to the cathedral.

I have lost count of all the parties that end with an enthusiast proposing we go hear *mariachis*, and the tired majority rules in favour of getting *tacos*. However, I do remember the dawn when an architect spoke of a theme improbable for those hours, the sinking of the cathedral. 'The nave sinks and the apse stays there.' An ashtray was the nave and a sugar-bowl the apse. The challenge to the architects, he explained, is to sink the apse at the same rate as the city: two metres per year, since the Aztecs dried up the lake. I remember the ditch from whence I pulled out my arrowhead. Maybe this encouraged me to return.

I lingered before the altar of the angels and went out to the courtyard, where labourers and artisans ask for work, exhibiting their tools on the pavement. I saw plumbers' soldering-pipes, carpenters' handsaws, a long row of hammers.

'179,' I said. There were not that many hammers, but the man knew to what I referred.

This time I received a more complex command. I had to record all the telephone numbers that began with 73 or 48 and dictate them to a public scribe in the Saint Domingo Plaza. The 'Evangelist' had just lent his services to write a love letter for an illiterate boyfriend, when he turned to me, as if remembering something. He pointed to the pigeons that fluttered around the plaza and farther away, the old faculty of Medicine. He asked me for a blueprint of the medical museum and, without a hint of continuity, an inventory of the organ grinders.

I don't know why I conceded to perform this and other tasks. I never repeated a command, nor did I ever again see the person who requested it. My life became complicated, perhaps more interesting; I went to steam baths, to the dense canal, the sole remains of the old lake, to a ring where lightweight boxers train, to a dancehall where 'Sonora's

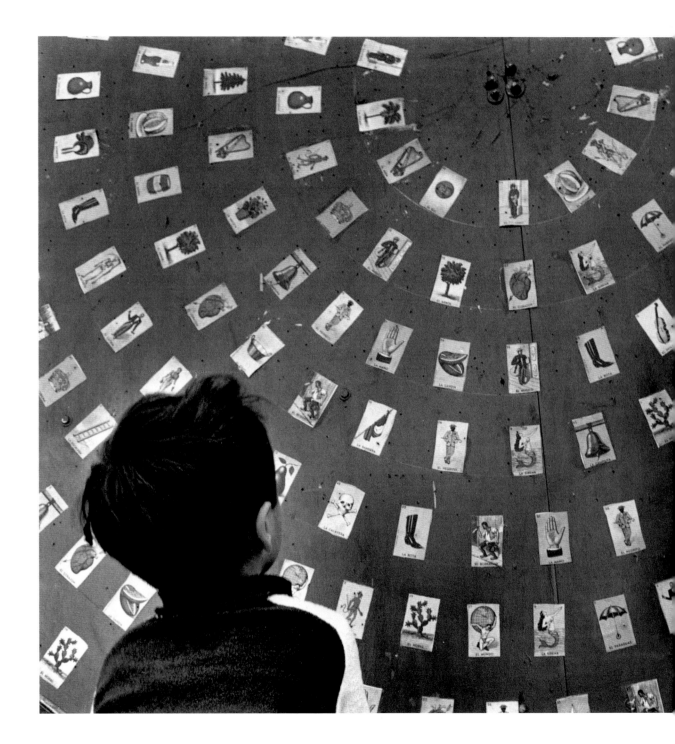

The Fortune, Mexico City ● **Yolanda Andrade**

The Fortune, Mexico City ● **Yolanda Andrade**

Dynamite' explode their trumpets, to the wholesale market where they trade vegetables at dawn, to a residential quarter where money favours deliriums (I saw a Tudor castle with Mayan frets, a mosque with medieval turrets, an adobe mansion with a tiled roof). Some of the commands were of an unhealthy minuteness; aggravating. Even so, I did not protest. I traced the route of the disappeared urban Sonora-Jamaica-Peñón autobus; I took an inventory of the animals that comprise the immense roof ranches, another of the pharmacies with churchlike names. I interviewed the jugglers and fire-eaters that beseige motorists; I filled entire cassettes with the cries of prophets who foresee the Apocalypse outside the marketplaces; I followed sequined women who pass through an oyster bar and vanish in the darkness up an uncertain alley. I copied endless graffiti: *The constellations are worn out* on the pink fence of a convent in Tlalpan, *Smoke a wall* on the palace of a Spanish conqueror in Coyoacán, *Kafka!* on a dead-end street in Chimalistac. Early one morning, I found myself counting electric cables among the dust clouds of Chalco. One cable hung to the ground. Somehow I knew it was a dead cable, one I could touch without risk. I picked it up and followed it down the streets of dust that smelled of excrement and fried onion. The garbage – which at times formed houses – was lost on the horizon, the wind brought papers from afar. I coiled the skein around my arm; behind me the dogs barked, yellowish dogs made for obstinate resistance, made to sleep in underpasses and eat cardboard boxes, cucumbers and piquant sauces. I could not find the post where the cable had been born: the sky of Chalco was a ravenous network which swallowed infinite cables of stolen light. I left that city lost in the city by following an old man who carried a stick from which hung two buckets of water. I was at the point of throwing my arrowhead into a ditch filled with detergent suds.

The next inquiry had to do with the population. I was born in a city of 3 million inhabitants; now we are between 18 nd 20, no one knows for sure. Which cities fit in the difference? I lost myself in the vain metaphysics of cramming Turin, Geneva and Arequipa into our margin of error.

With time, my labours became even more extravagant. I counted the times the wrestler 'Son of

Saint' fell, I gathered tri-coloured confetti in a meeting of the Official Party, I deposited letters in blind mailboxes, I slipped a counterfeit bill into the hand of a crossroads policeman, I counted the balloons shaped like octopi and the statues of bronze bureaucrats with their vests and ties in Alameda Park, I left a report in the 'Sun' gallery of the bullfight arena, I wrote an article about our 6 million rats and our 300 firemen. One night, by telephone, they asked me for five pages on the city for a gallery in London. This task of writing a compendium for a most certainly fictitious place produced in me a fit of troublesome lucidity, much too much like madness. It was then that I thought of the map. Until that moment, the roaming about the city had entertained me like an exploration, an escape with no other purpose but to make my working days unpredictable. For the first time, I suspected a logic, an intelligent design to the commands I had thought merely random. We served a plan. Far away, in another place, someone compiled the information that a multitude of dispersed men exchanged with swift words. I felt, perhaps with excessive pride, that we belonged to a sect, lovers of secrets and detail. Our accountings must have formed a hidden drawing. In the collective memory lives another city, malleable, capricious, ours; capable of making the labyrinth tolerable. To count the destroyed palm trees or the birds fallen in the dead air is by now a form of resistance, of retaining something of the city that exceeds and confuses us. Curiously, as soon as I felt the vertigo of obeying a superior, perhaps heroic, destiny, the commands ceased. I was sent to a false address, to a wall where there had never been a door.

Yesterday, in the house in front of my own – always a wall in front of another – a number appeared, written in lime. I think it means the end of my tasks. For some reason, the owners of the map don't want me to proceed. The number should be my recompense. Or something more: someone, somewhere, has classified me. I won't reproduce here the fatal cipher for fear of remaining fixed on the map. Suffice it to say that I spent hours sifting through my clothes and drawers in search of the obsidian arrowhead. I did not find it.

Juan Villoro

Translation: Amy Schildhouse Zabludovsky

Punk death, Mexico City ● **Yolanda Andrade**

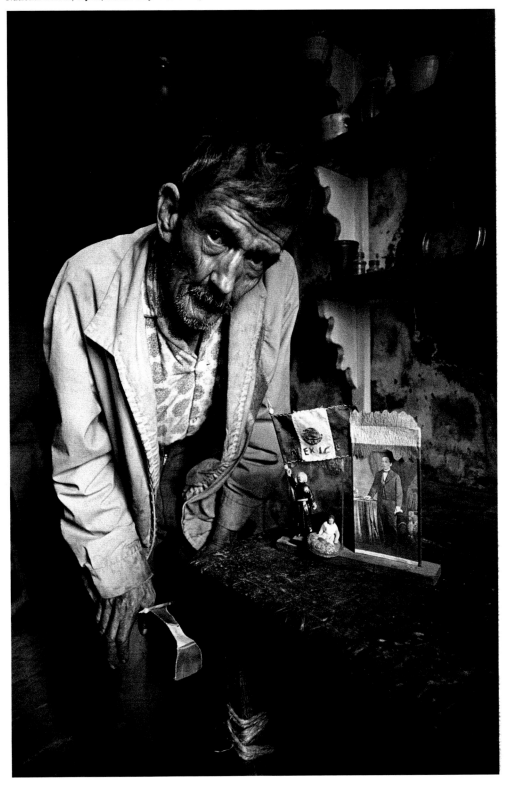

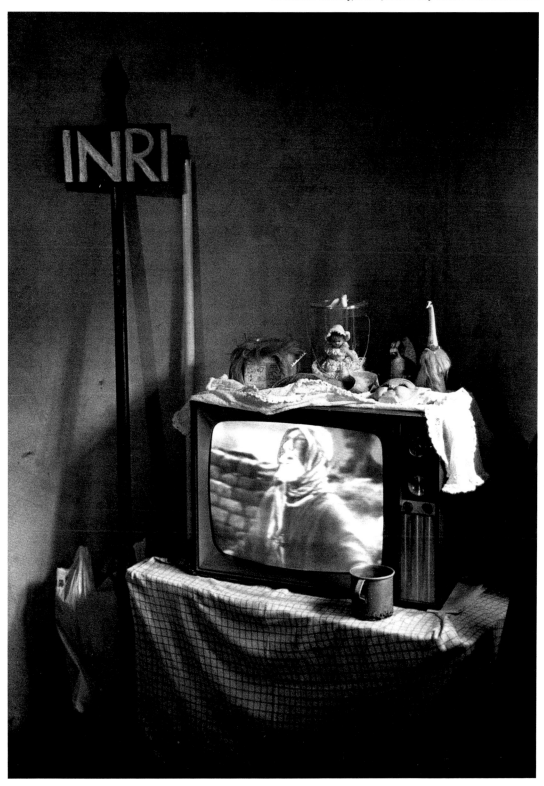

Accident on a construction site, Lomas, Mexico City ● **Fabrizio Leon Diez** (*previous page*)

The Virgin in Coyoacan, Mexico City ● **Pedro Meyer**

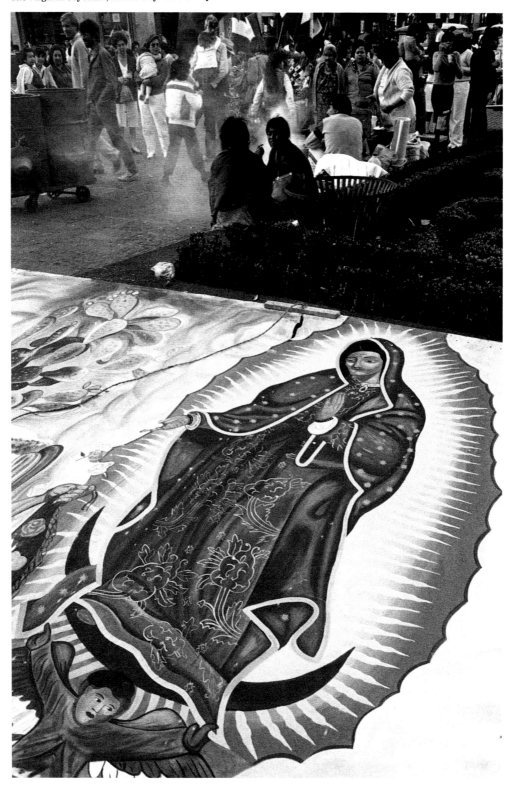

After the earthquake, Downtown, Mexico City ● **Fabrizio Leon Diez**

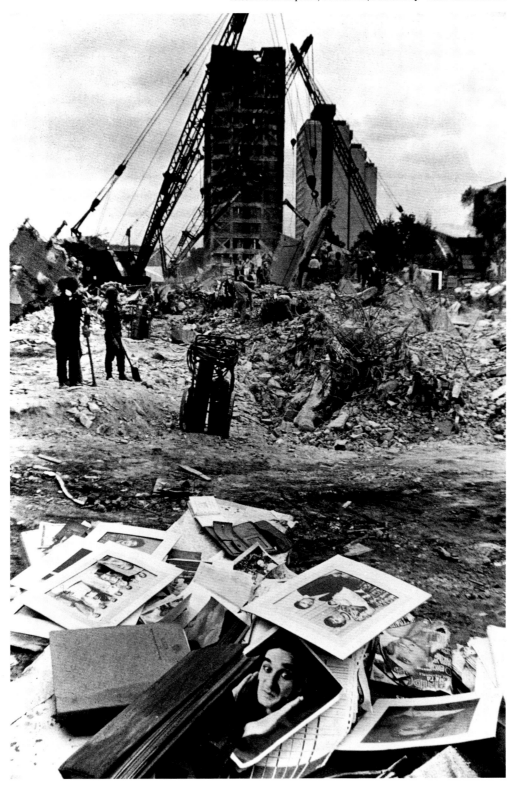

Prostitute and client, Downtown, Mexico City ● **Victor Flores Olea**

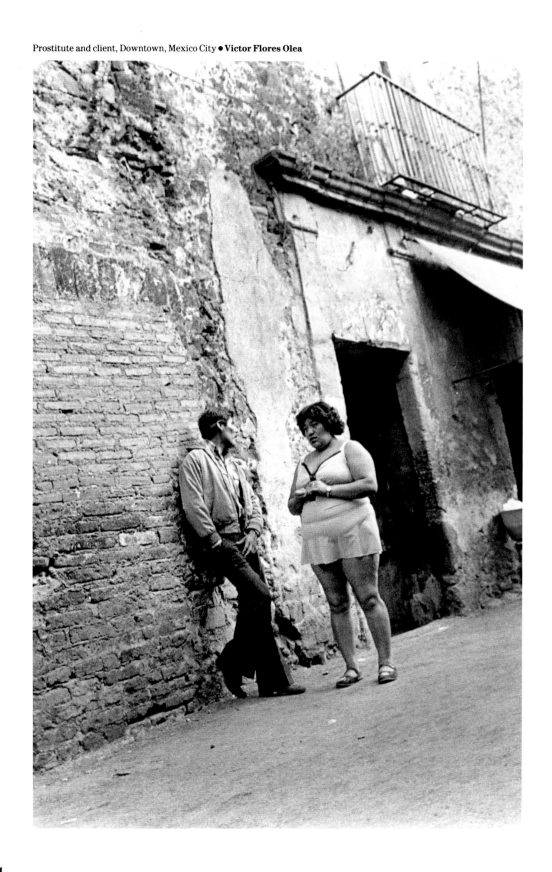

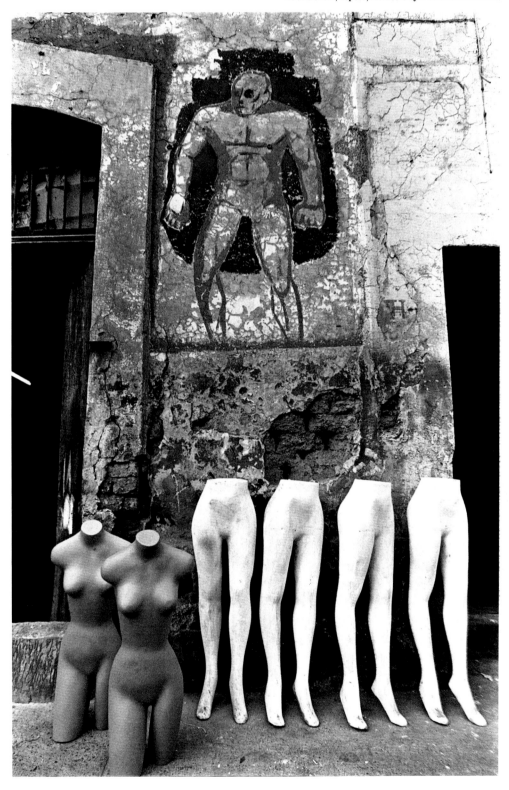

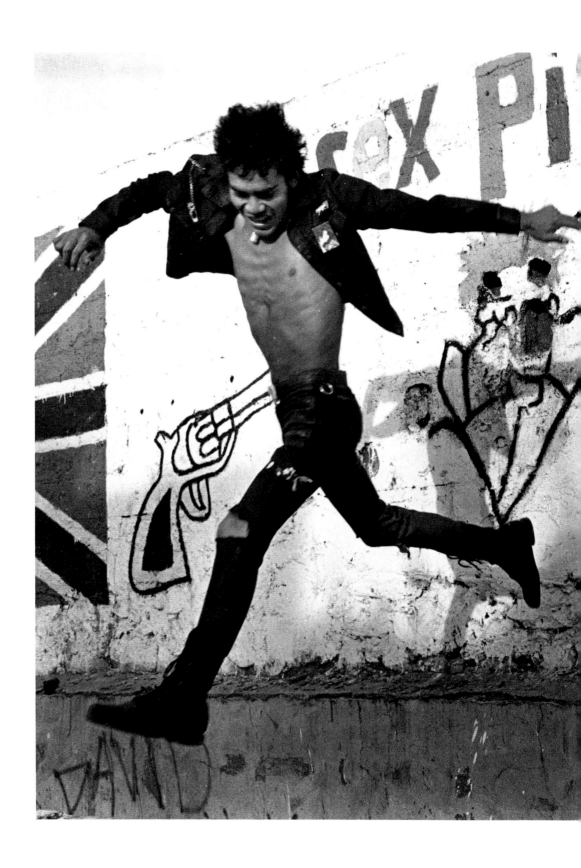

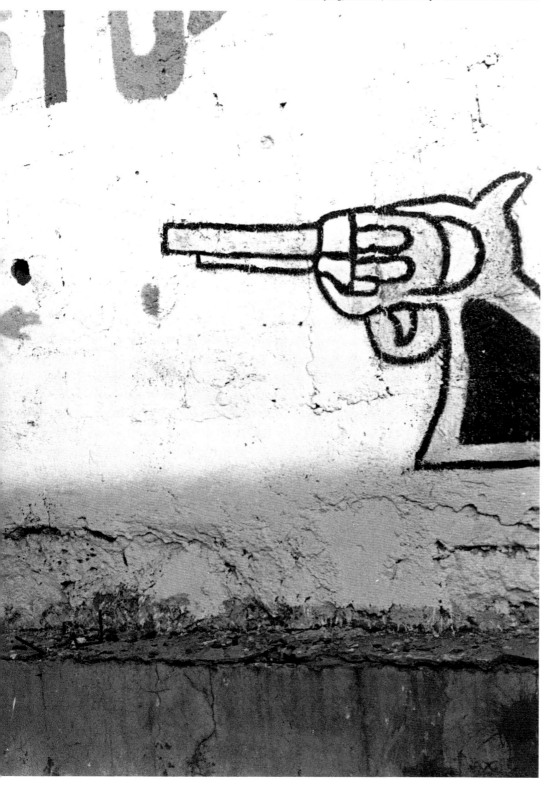

APPARITIONS

Ruben Ortiz

Cuauhtlatoatzin venerated the cruel and merciless Tonantzin. He was forced to abandon the rites and bloody sacrifices; 'The word is taught in blood' and the Bible was no exception. Cuauhtlatoatzin was baptized with the name of Juan Diego, and he soon understood that Christ's sacrifice on the cross was enough for him. He preferred to offer up his faithful love rather than his beating, dripping heart.

In December of 1531, on his way to Mass, he became aware of an apparition: the Virgin Mary entreating him, in the sweetest tones, to build a temple to hear the laments and remedy the pains, miseries and ailments of the dwellers of Anahuac, of which there were plenty. The temple was to be constructed on the very spot where Tonantzin had been worshipped for centuries.

Obviously the bishop did not believe him, and Juan Diego had to return in the hope that the Virgin would appear again. On his second visit, the Indian had no better luck, because he had no proof. The bishop sent some men to follow him and investigate, but Juan Diego mysteriously disappeared.

Juan Diego missed his third appointment with the Virgin because his uncle was dying of the plague and needed a priest to hear his last confession. The Virgin appeared none the less and miraculously saved his uncle's life. Also, a mass of beautiful Castilian roses appeared on Tepeyac hill, which would serve Juan Diego as irrefutable proof of the

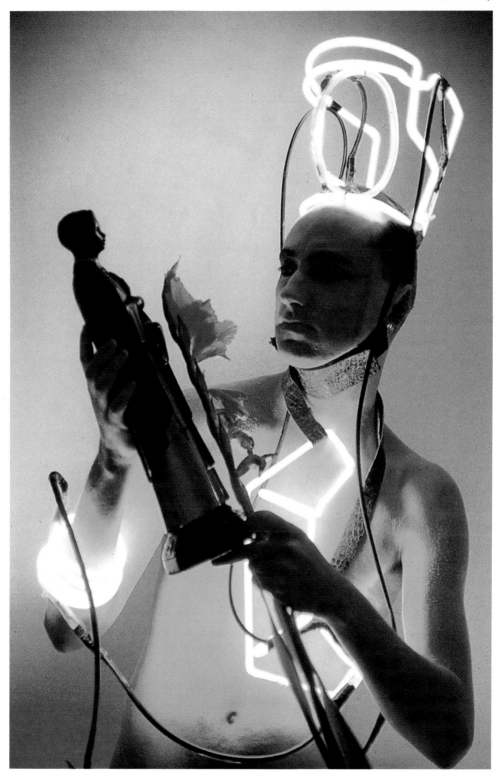

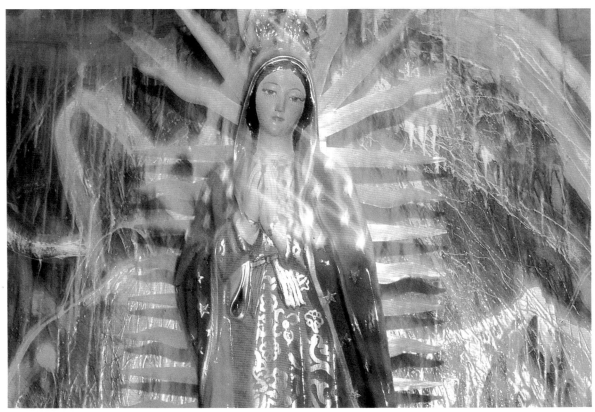

'Between heaven and earth', Tlalpan, Mexico City

Virgin's apparition, because such roses did not grow in Mexico, and much less in December. The faithful Indian gathered up the roses in his cape. When they were spread in front of the bishop, the gathering became aware of yet another miracle: the image of the Virgin had appeared on the cape. Crying and convinced, the bishop ordered the immediate construction of the temple to praise the image of the Virgin of Guadalupe.

In October of 1989, another miracle happened. In a small town, a pressure cooker exploded. On the roof, the explosion left behind traces of beans in the exact shape of Our Lady of Tepeyac. The cook, too, was miraculously unhurt by the explosion. The next day, a further explosion only served to complete the image. Soon, pilgrims and the press had appeared, too.

Ever since the apparition of the Virgin of Guadalupe, Queen of Mexico, Empress of America, this miracle has been open to charges of illegitimacy. Many never believed the event (which is based on very flimsy evidence), and it is even said by Mexican scholars that the Virgin was painted by an Indian called Marcos Cipac.[1] None the less, we could also believe that the Virgin's image miraculously appeared before the painter's eye so that he could portray her. Others saw the Indian devotion of the image as a continuation of pre-Hispanic paganism. But in a country with a Spanish élite, a dark-skinned population and a political regime built on the ruins of an Indian empire, the contradictions inherent in the Virgin's image have only helped to strengthen her hold on Mexico. For the many different peoples who inhabit Mexico, an image with a Spanish name, dark skin, and a sanctuary built on top of an earlier Indian temple provided a spiritual common denominator that all could relate to. Through it, and in it, we could express our needs and fears. We could ask for protection against disasters, and bask in the certainty of its favour, manifested in the love this mother had for Mexico. Never mind that we will never agree on the ultimate meaning of the image and its cult. We can simply stand side by side in the processions, sit together in the church and rejoice in these incontrovertible demonstrations of unity. That

Monroe in a recent exhibition. This public outcry was such that it almost caused the closure of the museum and the forced resignation of its director.

In this sense the Virgin is not a purely religious phenomenon. Through its cult people seek aesthetic satisfaction, the thrill of ritual, and a sense of richness that is never so easy to get in 'real' life.

The Virgin of Guadalupe is depicted figuratively in the colonial style of her time. She is dressed in the prevalent manner, and her pose, for that age, is a bit too static and hieratic. For a good baroque painting there were better artists than God.

If the Virgin were to appear right now at the end of the twentieth century what medium and style would God use?

Ruben Ortiz Translation: Frederico Navarette; Julian Brody

Translator's Note:

1. Edmundo O'Gorman, *Destierro de Sombras*. Universidad Autónoma de México, México, 1986. pp. 13-14.

'The family', La Alameda, Mexico City

is what images are for. It is therefore no surprise that the Creole priest Miguel Hidalgo chose the Virgin of Guadalupe as the banner of his movement for Mexican independence from Spain, just as the Chicanos or Televisa (the powerful Mexican private television network) use this emblem for their own needs to engage the support of the population.

In a country where there has been a high rate of illiteracy, images hold great importance. From the pre-Hispanic codex, religious icons, pop culture and television to the most accomplished examples of social realism, images have taught history, ridiculed tyrannies (as in the case of Posada's engravings), bolstered nationalism and provided enjoyment. Even today comics are the most popular form of literature. But no image has been as widespread as the Virgin of Guadalupe. It is held in such reverence that it could provoke a massive disturbance, with enraged tumults of people unused to museums protesting about the Mexican Museum of Modern Art's inclusion of an image of the Virgin with the face of Marilyn

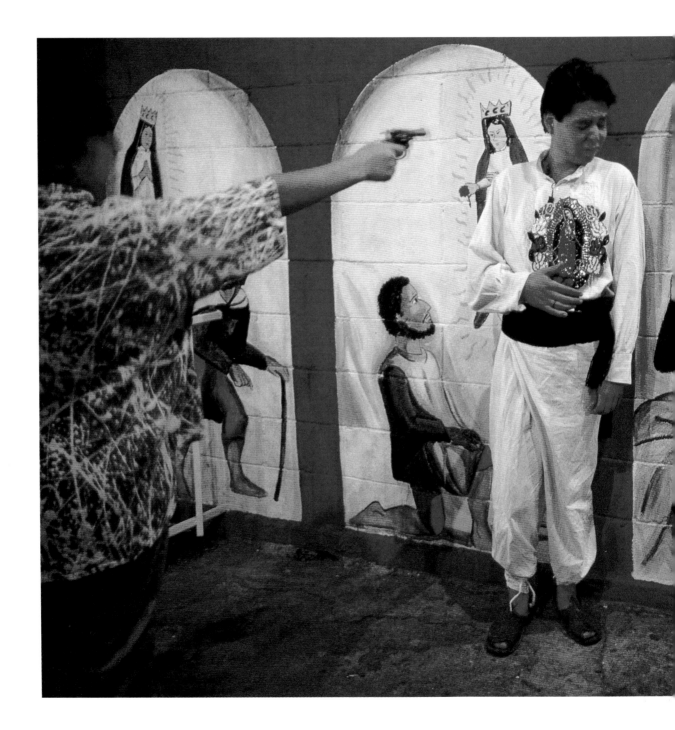

'Death in Villa', Mexico City

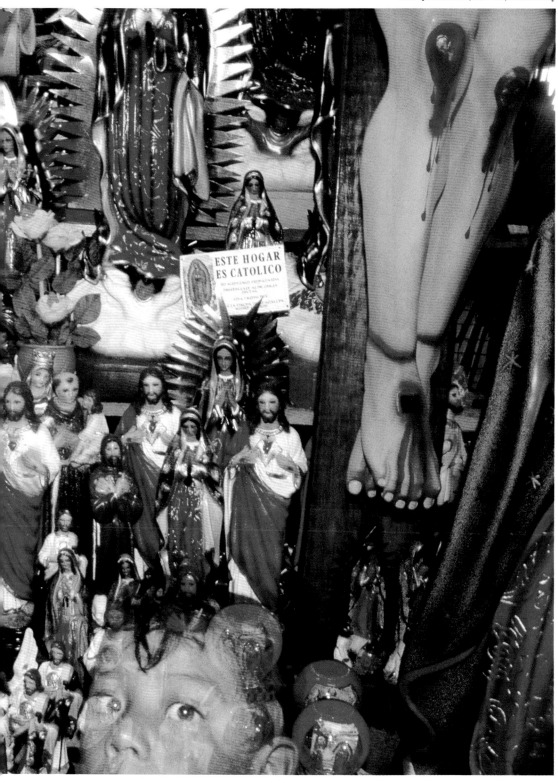

ESTE HOGAR
ES CATOLICO

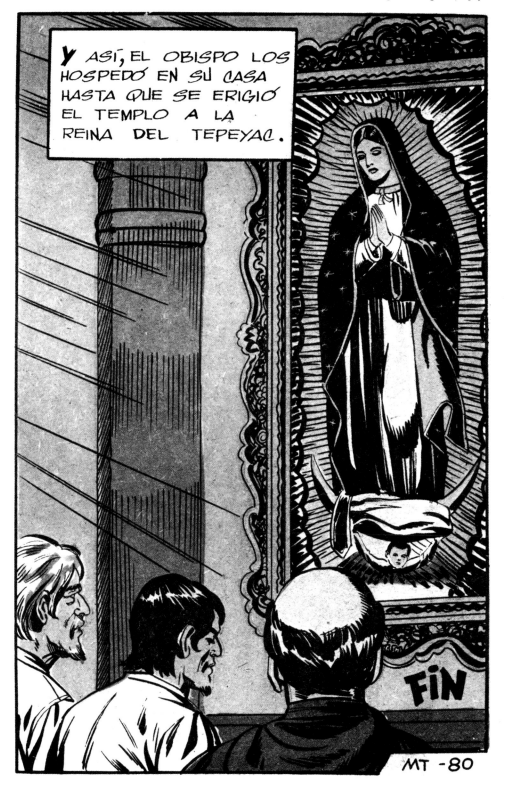

PHOTOGRAPHERS

ALICIA AHUMADA, born in 1956 in Santa Tomas Chihuahua, is a self-taught photographer. She worked as a restorer of vintage prints at the Fototeca of the National Anthropological Institute in Pachuca, Hidalgo. She was also involved in a major project on migrant labour with the University of Hidalgo.

YOLANDA ANDRADE, born in 1950 in Tabasco, came to Mexico City in 1968. She studied photography at the Visual Studies Workshop in Rochester, New York from 1976. In 1988 she published her first book of photographs, *The Transparent Veil*.

ADRIAN BODEK, born in 1953 in Mexico City, studied photography in New York. He returned to Mexico and in 1978 received a grant for his work in the state of Morelos. In 1989 he exhibited in Mexico City work from East Germany.

PABLO CABADO, born in Buenos Aires, Argentina, in 1963, moved to Mexico in 1981, and has been a practising photographer since 1984. He was a student of Pedro Meyer in the workshop, 'Taller de los Lunes'. He has shown his work in Cuba, Mexico, Italy and the USA. In 1989 he won the International Center of Photography's, Young Photographer of the Year Award.

MARCO A. CRUZ, born in Puebla in 1957, studied painting at the University of Puebla. He has been a photo-journalist for 8 years. He received a prize for his photography, in 1976, from the Socialist Party of Mexico. He is a co-founder of the press agency, *Imagen Latina*. He now works for *La Jornada*, a Mexican daily newspaper.

JOSE HERNANDEZ CLAIRE, born 1949 in Guadalajara, has been photographing the blind since 1984 and received an award for this work from both Nikon and the World Health Organisation. In 1989 he received a scholarship from the 'Consejo Nacional para La Cultura y Las Artes' to work on a project concerning ecology in his native city.

FLOR GARDUÑO, born in Mexico City in 1957, studied Visual Art at the Escuela Nacional de Artes Plasticas San Carlos, UNAM, in Mexico City. Between 1978-80 she was an assistant to Manuel Alvarez Bravo. She has shown her work in Spain, France, The Netherlands and the USA. She has published two books, *Magia del Juego* and *Bestiarium*.

VICTOR FLORES OLEA, born in Toluca in 1932, is a photographer, writer and politician. In 1975 he was Mexico's Ambassador to the Soviet Union and from 1979-82 Mexico's respresentative at UNESCO. He has exhibited his work in Europe, Japan and the USA. His book of photographs, *Los Encuentros*, was the first book of the series *Rio de Luz*, produced by the Fondo de Cultura Economica. He is at present the President of the Consejo Nacional para La Cultura y Las Artes.

FABRIZIO LEON DIEZ, born in 1962, studied at the Escuela Nacional de Artes Plasticas in Mexico City, and works as a photo-journalist for the newspaper *La Jornada*. In 1988 he won a Mexican Bienal for photography. Recently he shared a joint BECA (award) from the Funda Nacional de Cultura y Las Artes for 1990 with his colleague Francisco Mata Rosas.

ENIAC MARTINEZ, born in Mexico City in 1959, studied Art at the San Carlos Academy. He has worked also as a painter and musician. In recent years he has focused on photography. In 1988 he received a Bienal Award. Eniac studied photography at the Institute of Contemporary Photography in New York. He received a Fulbright Award in 1989 for his work on the Mixteco Indians.

FRANCISCO MATA ROSAS, born in 1958, began working as a photographer in 1986. He studied photo-journalism at the Metropolitan University and works for the newspaper *La Jornada*. He received a BECA (award) for 1990.

PEDRO MEYER, born in Madrid in 1935, emigrated to Mexico at the age of two. In 1974, after his first one person show, he decided to devote himself to photography. Since then he has written, curated and lectured. He was the founding President of the Mexican Council of Photography, and the organiser of the three Colloquiums of Latin American Photography held in Mexico City in 1979 and 1981; the third in Cuba in 1984. He has published three books: *Tiempos de America*, in 1985; *Espejos de Espinas* in 1986, and recently in 1988 *Los Cohetes duraron todo el dia*. At present he is photographing his personal vision of the

138

United States, a project supported with a Fellowship from the Guggenheim Foundation received in 1987.

PABLO ORTIZ MONASTERIO, born in Mexico City in 1952, studied photography in Britain at the London College of Printing in 1975. He published a book on a fishing community in the south of Mexico, *Los Pueblos del Viento*. He has been involved in the design and editing of the series *Rio de Luz*. In 1989 he was the co-ordinator for the 150 Years of Photography in Mexico. At present he is working on a book on Mexico City.

RUBEN ORTIZ, born in 1964, studied visual arts at the San Carlos Academy in Mexico City, and architecture at Harvard. While he works and exhibits primarily as a painter in Mexico and the United States, he has been involved with photography in Mexico, and in 1984 won the photography Bienal award. He will be working with the support of a Fulbright Award during 1990.

PEDRO VALTIERRA, born in 1955, is a self-taught photographer, well known internationally as a photo-journalist. In 1983 he received the first Mexican Biennal photography award and has won several awards for photo-journalism. Outside of Mexico he has exhibited his work in Canada, Cuba, Belgium and Chicago, USA.

MARIANA YAMPOLSKY, born in 1925, worked as an engraver in the Taller de Grafica Popular. As a teacher for many years, she worked on the primary school textbooks for the Secretary of Education in the area of natural sciences and coordinated a two year literary project for children, *Colibri*. Her own photographic publications include *La Casa en la Tierra, La Casa que Canta, El Raiz y el Camino, La Estancias del Olrido.*

Day of the Dead, Mexico City ● **Francisco Mata Rosas**

WRITERS

CARLOS MONSIVAIS, born in 1938, is a writer and journalist. He has published three anthologies (Mexican poetry, short stories and literary articles), five volumes of social and political chronicles and a book of religious or irreligious fables: *Nuevo Catecismo para Indios Remisos.*

AUGUSTO OREA MARIN, born in 1928 in Oaxaca, is a homeopathic doctor and specialist of pre-Hispanic herbal medicine. In 1967 he won an award in Halisco for literature and has published numerous books on art and pre-Hispanic culture.

ELENA PONIATOWSKA, born in 1933, has been publishing interviews and essays in newspapers and magazines since 1953, and has been awarded the National Prize of Journalism. As a writer she has published *Massacre in Mexico, Dear Diego, Here's to you kid Jesus, You come by night* and other novels and short stories. She is known for her active participation in political and cultural events.

JUAN VILLORO, born in Mexico City in 1956, is the author of two short story books *La Noche Navegable* in 1980, and *Albercas* in 1985; a collection of non-fiction writing: *Tiempo Transcurrido* 1986; a travelogue to Yucatan: *Palmeras de Las Brisa Rapida* 1989, and a children's book: *Las Golosinas Secretas.*

ERACLIO ZEPEDA, born in Chiapas, Mexico, in 1937, is a poet and narrative writer of short stories dealing with many themes: Indian and urban; death and magic realism. An incessant traveller, actor, and active politican for the opposition party, and a member of congress. His books have won national prizes. He is well known for his gifted impromptu narration.

TRISHA ZIFF, editor, now lives and works in Mexico City. In 1982 she received a Gulbenkian Award to work in the North of Ireland. She returned to England in 1985 as director of the photographic agency *NETWORK* in London. In 1989 she compiled and edited a photographic book on the North of Ireland, *Still War,* with an Arts Council award.

Coyoacan, Mexico City ● **Pablo Cabado**

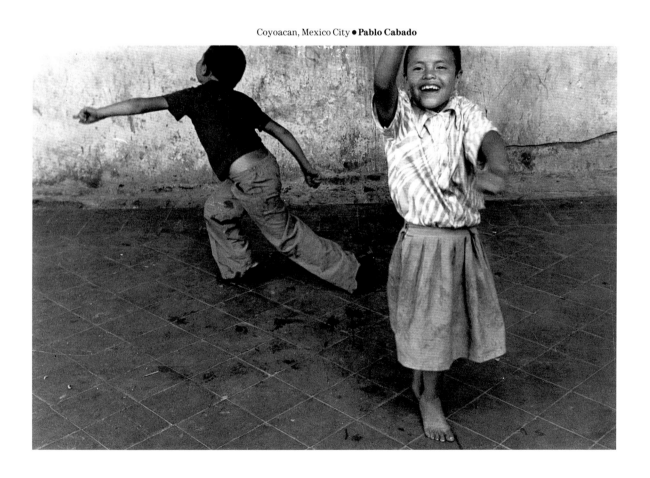

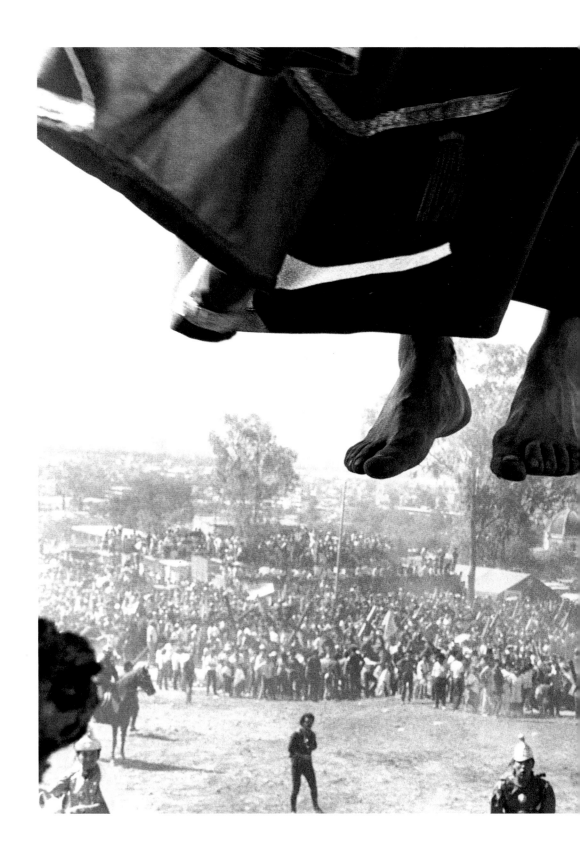